IMAGES
of America

SAN JOSE'S
HISTORIC DOWNTOWN

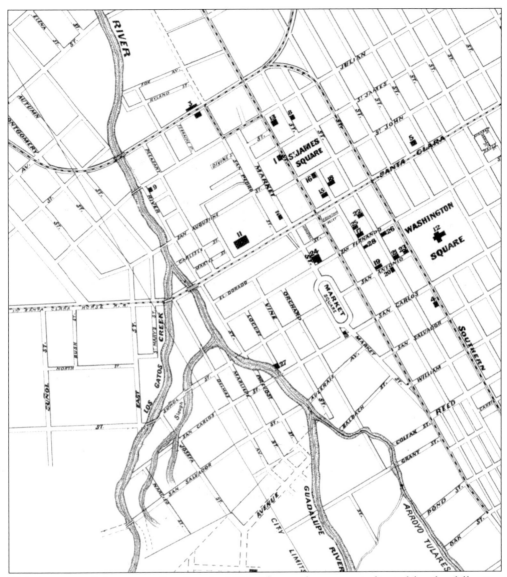

This is a map of downtown San Jose in 1872. Places of note are indicated by the following numbers: 1. Santa Clara County Courthouse, 2. First San Jose City Hall, 5. Horace Mann School, 12. San Jose Normal School, 16. Trinity Episcopal Church, 18. First Presbyterian Church, 21. Bickur Cholim Synagogue, and 24. Saint Joseph's Catholic Church.

IMAGES
of America

SAN JOSE'S
HISTORIC DOWNTOWN

Lauren Miranda Gilbert and Bob Johnson
San Jose Public Library

ARCADIA

Copyright © 2004 by the City of San Jose
Written on behalf of the City of San Jose by the San Jose Public Library
ISBN 0-7385-2922-2

Published by Arcadia Publishing
Charleston SC, Chicago IL, Portsmouth NH, San Francisco CA

Printed in the United States of America

Library of Congress Catalog Card Number: 2004110889

For all general information contact Arcadia Publishing at:
Telephone 843-853-2070
Fax 843-853-0044
E-mail sales@arcadiapublishing.com
For customer service and orders:
Toll-Free 1-888-313-2665

Visit us on the Internet at www.arcadiapublishing.com

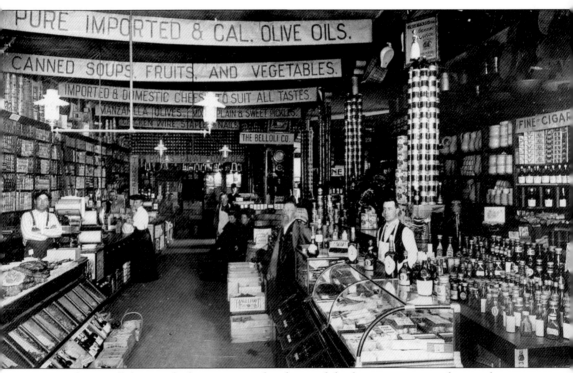

Joseph A. Belloli owned what was considered one of the largest grocery and general stores in San Jose in the late 1800s. He began with a modest establishment on the northeast corner of San Fernando and Third Streets in 1876, but eventually built the Belloli Building (which housed other businesses) on the opposite corner. The Belloli family business survived both fire and earthquake and did not close its doors until 1918.

CONTENTS

ACKNOWLEDGMENTS

Many people assisted us with this project, some without even realizing it, and we'd like to acknowledge them here. First and foremost, this book would not exist without the incredible resource of the Clyde Arbuckle photograph collection, which is now owned by the San Jose Public Library. We estimate that more than 80 percent of the photographs in this book come from the Arbuckle collection. Mr. Arbuckle was the San Jose city historian for over 50 years. He died in 1998, though his presence has been felt guiding us throughout this process.

This book also would not exist without the support of the administrative staff of the San Jose Public Library, our employers. By giving us the green light to research and assemble this publication while still tending to our other work duties, we were able to proceed. We'd especially like to thank Lisa Rosenblum for her unwavering support, as well as Jane Light, Ned Himmel, Anita Phagan, and Elsi Stotts for "keeping their eye on the prize" and helping us wade through contract negotiations and other snags along the way. We are proud to have produced this book, and are happy to see the proceeds go to support our library.

Lauren would also like to thank the SJPL Reference staff, which ended up with many of her desk hours while she holed up doing research and writing text. Lauren gives special thanks to Joan Bowlby, manager of reference services, and most especially to Sandy Garcia, for creating space on the schedule for Lauren to work on the book.

Bob would like to thank Steve Groth for use of the Gordon Collection photographs from the San Jose State University Special Collections and Archives. Special thanks also go to Bob's colleagues Lucille Boone, Ralph Pearce, and Judy Strebel for their help and support.

We are indebted to several local historians for their kind assistance, as we often searched for clues to mysteries in one photograph or another. We are most grateful for the enthusiastic inspiration of Sourisseau Academy Executive Secretary Charlene Duval, who tirelessly assisted us with this project, and allowed use of Academy photographs. Charlene's detailed and astounding knowledge of San Jose's history, as well as her love and dedication to the subject is breathtaking to behold. Thanks also to April Halberstadt, Bonnie Montgomery, Jack Douglas, and Leonard McKay.

And finally, thanks to our editor Hannah Clayborn—for her wise words, humor, and general aplomb—she helped make the project fun.

We would also like to thank our friends and family for their support and encouragement.

Lauren Miranda Gilbert Bob Johnson
Reference Librarian California Room Librarian
San Jose Public Library San Jose Public Library

INTRODUCTION

How will we know it's us without our past?
–Leonard McKay

Local historian Leonard McKay posed this provocative question in October of 1972 to a crowd gathered for the dedication of San Jose's 1895 post office as a California Historic Landmark. Standing on a platform near San Jose Mayor Norm Mineta and other local dignitaries, McKay told the crowd of several hundred that they stood on land once occupied by the Pico Adobe. He spoke of the early pueblo days of San Jose, of the site of the first State Legislature just across City Plaza, of the comings and goings of different eras in downtown. Throughout it all, he repeatedly asked, "How will we know it's us without our past?"

Without tracing our history, we cannot really know a city, cannot know the intricate tapestry that the passage of time has woven. This tapestry is made up of the rich and colorful threads of people, buildings, events, and stories that make each town unique. It is our desire here to offer glimpses of the many layers of San Jose, as it has rewoven itself again and again over many eras. While many cities throughout the United States share certain parallels and similarities in their past, none have exactly the same historical fingerprint. And while photographs only capture moments in time, these images placed side by side reveal the heart and soul of this city.

The photographs in this book are by no means an exhaustive study of San Jose—more a cross-section of images based on the particular strengths of our collection. Only occasionally do they bring the reader up to present-day San Jose. Our focus is a portrait of downtown in the days before silicon chips and big business. Before it was "The Capital of Silicon Valley," it was known simply as "The Garden City." Visitors came to see the breathtaking views of blossoming orchards that grew around San Jose. We include images from the days when Santa Clara Valley residents knew downtown San Jose as a market town serving the needs of local farmers, as well as more modern times when downtown struggled to find its identity.

Before World War II, downtown San Jose served Santa Clara Valley's shopping and business needs. With the housing boom that followed the war, however, stores and branch offices of banks opened up in developing neighborhoods outside of downtown. This movement gradually drained both residents and business from the area. Only in recent years is downtown once again becoming a focal point of San Jose.

Though photographic history does not extend to the earliest days of San Jose, it should be noted that we live in California's first civil settlement. It was founded here in 1777, on the site of the current City Hall on North First Street. The first Europeans passed through Santa Clara Valley in 1769, and the town of San Jose was later envisioned as an ideal midpoint for creating

crops to feed the residents of the presidios of San Francisco and Monterey. Through a relatively brief stint under Mexican rule followed by the Bear Flag Revolt in 1846, San Jose emerged as the first American capital of California in 1849.

After its short-lived reign as state capital, San Jose moved into its next era as a market town for the growing agricultural industry, which it remained for many years. As the valley around it has grown and changed, San Jose has been altered and has reflected those changes. As the technology industry grew and subsumed the focus on farming, San Jose was deeply affected. Now in its 227th year, San Jose will no doubt continue to grow and evolve.

Sadly, many colorful buildings and landmarks have been lost through the years as San Jose has struggled to define itself. As with many cities across the country, whole blocks have been bulldozed, leaving old-timers lost on once familiar streets. Yet there remain traces of old San Jose in this ever-changing town. The tapestry of downtown is still being woven. We hope you enjoy this glimpse back through some of the earlier layers of San Jose. Exploring the many eras of a city is akin to spending time with an acquaintance who eventually becomes a friend. It is our wish that peering into the past days of downtown San Jose in these pages will spark a deeper friendship between you and this fair city.

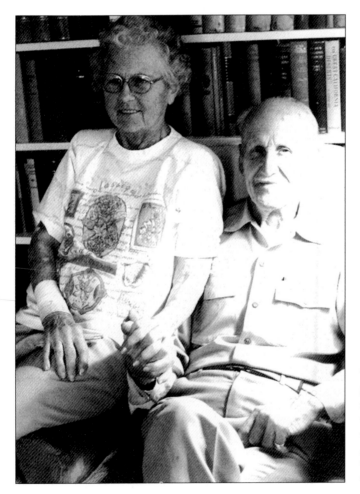

We dedicate this book to San Jose City Historian, Clyde Arbuckle (1903–1998), seen here with his wife, Helen Fisher Arbuckle (1908–1998), without whom this book would not exist.

One

EARLY DAYS

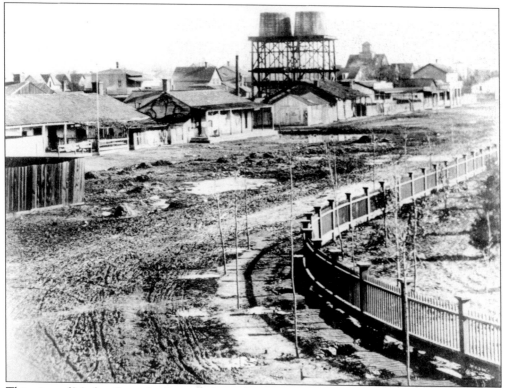

This view of Market Street looking southeast from San Fernando Street shows the twin tanks of the first public water service erected in November of 1866. The surrounding buildings were part of Chinatown, which stretched slightly north and east of this photograph. It's hard to imagine the Fairmont Hotel Annex, which stands in the place of these water towers today. Further down this muddy street, where we see the white structure of the Eagle Brewery facing San Carlos Street, we would find the Hotel Sainte Claire. It is all so unrecognizable, and yet, the curve surrounding City Plaza is unmistakable. (Courtesy of the Sourisseau Academy.)

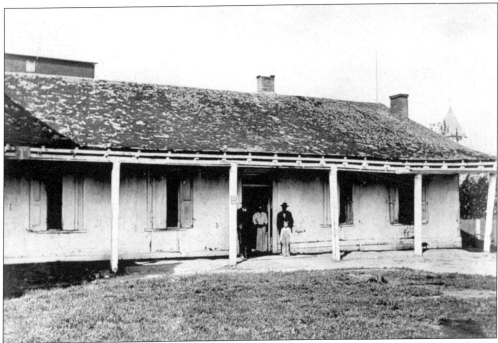

This adobe was thought to be the oldest building in San Jose at the time the photograph was taken. It is larger than the typical adobe dwelling, which is why the photographer may have referred to it as the "mansion." We do not know where it was located, only that it did not survive San Jose's march of progress.

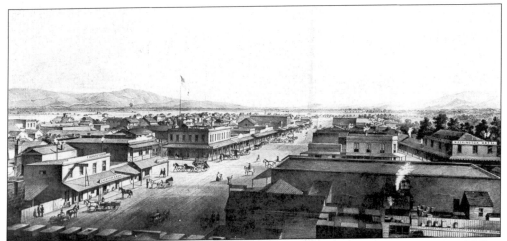

This lithograph of San Jose in 1858 is our earliest view of downtown. Taken from City Hall, a castle-like structure that was built on the northwest corner of Market and Santa Clara Streets in 1855, this rendering shows how tiny downtown was compared to the sprawl of San Jose today.

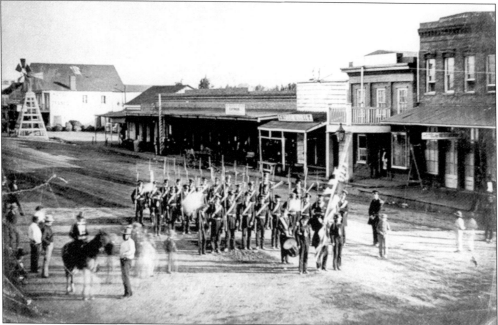

The San Jose Militia marches south on Market Street in this photo taken about 1860. The soldiers appear to be wearing uniforms from the period of the 1846 war with Mexico. The white building to the right of the windmill is the Hotel France.

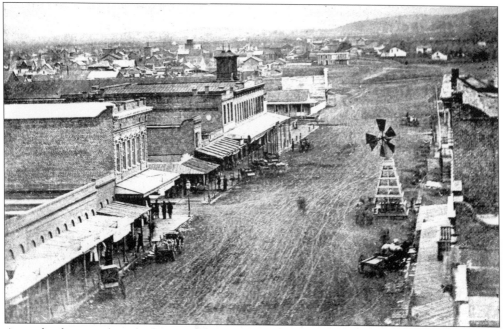

An agile photographer climbed to the rooftop of an unknown building on Market Street just north of El Dorado (now Post) to capture this dramatic view of southeast downtown San Jose in the late 1860s. The small, two-story building on the far left is the Murphy building, which was the subject of much debate before it was demolished in 1976. The windmill directly across from it pumped water into a nearby cistern for fire department use.

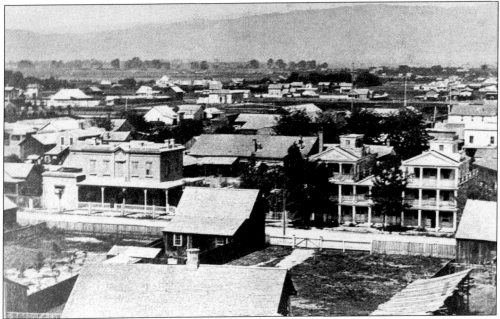

This photographer pointed his camera northeast from the rooftop of the College of Notre Dame on Santa Clara Street in about 1866. The three-storied, multi-balconied United States Hotel stood facing the east side of San Pedro Street. Several blocks east lay the land that became St. James Park in 1869. Note that the land east of Seventh Street was still countryside, dotted with oaks.

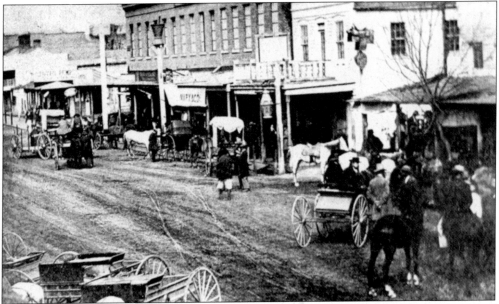

Here we see a bustling day on First Street in 1867, looking north towards the intersection of Santa Clara Street. The large, multi-windowed structure on that corner was Adolph Pfister's general store, which spread east onto Santa Clara Street all the way to the corner of Second Street. This corner is now the site of the 13-story Bank of America building, a feat of engineering that was unimaginable in 1867.

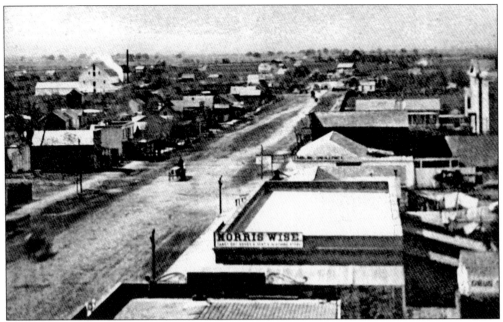

Looking west on Santa Clara Street in 1867, the road curves out of sight towards the Alameda. A narrow wooden bridge crossed the Guadalupe River, which disappeared around the turn at Los Gatos Creek. This view was taken from the roof of the Hensley House, which stood on the northwest corner of Market and Santa Clara Streets. One rarely had to battle traffic on Santa Clara Street in those days.

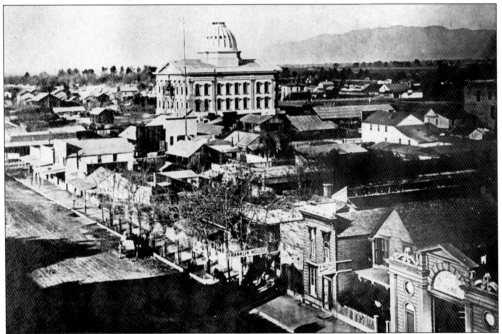

Downtown is pictured from the roof of San Jose's first city hall. The view northeast is dominated by the bulk of the Santa Clara County Courthouse, which had just been completed when this photo was taken in 1868. The street partially in shadow on the left is Market Street.

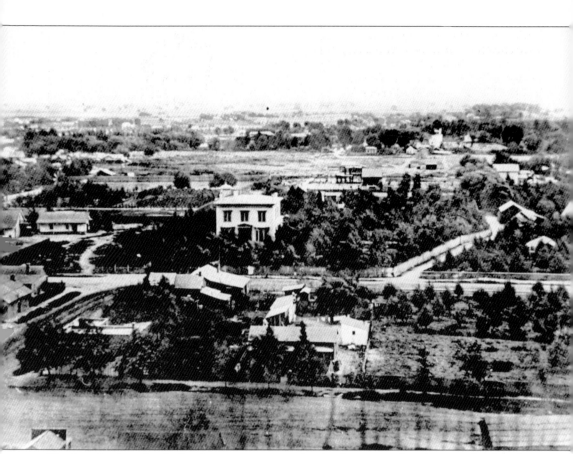

The low density of early San Jose structures can be clearly seen in this photograph taken from the dome of the Santa Clara County Courthouse in 1868. The view is looking east, with Market Street in the foreground and San Pedro Street in the center. Remarkably, two of the structures shown here still exist today. The white Italianate house in the center is the Fallon House, built in 1855 by wealthy businessman and early San Jose mayor Thomas Fallon. The small white building to the left of the Fallon House is the Peralta Adobe. The Peralta Adobe is the oldest building in present-day San Jose and the only one surviving from San Jose's early Hispanic period. Some of the grounds of the City Nursery, owned by Louis Pellier, are visible to the right of the Fallon House.

Louis Pellier came to San Jose in 1850 and established the City Nursery. Since the local soil and climate reminded Pellier of his native France, in late 1856 he imported 500 pounds of French plants, seeds, and cuttings. Among them was a prune, "la petite prune d' Agen." In later years local cultivation of this little prune became a multimillion-dollar industry and the main agricultural crop of Santa Clara County.

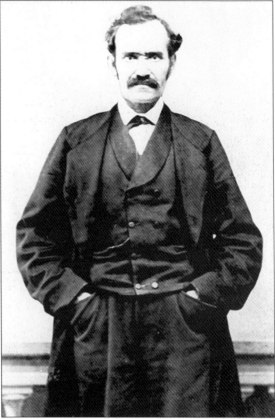

This was San Jose's Chinatown about 1880. Over 1,000 people were crowded into this one-square block along Market Street between San Fernando and San Antonio Streets. With the rise of anti-Chinese sentiment in California came increasing calls to remove Chinatown from downtown San Jose. On the afternoon of May 4, 1887, a fire of suspicious origin broke out in a Chinatown alley. By early evening Chinatown had been completely destroyed. (Courtesy of the Sourisseau Academy.)

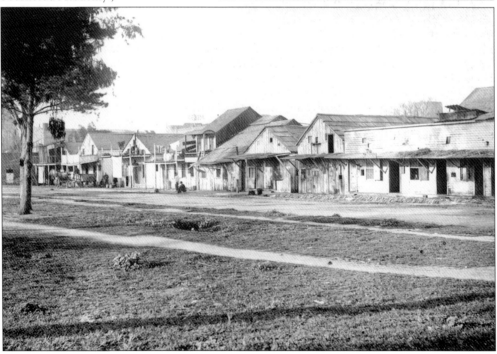

Daniel Murphy, one of the five sons of Martin Murphy Sr., owned this home on South First Street. The Murphys were among the first to cross the Sierras by wagon train in 1844. Like his father and brothers, Daniel had good fortune and eventually owned nearly 2,000,000 acres of land. Though his main home was near Gilroy, he had a particular fondness for this home in downtown San Jose.

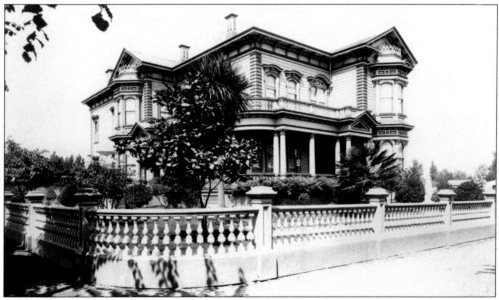

Daniel Murphy's wife did not share his fondness for the house on South First Street. After her husband's death in 1882 Mary Murphy moved to this spacious new abode at the northwest corner of Fifth and William. (Courtesy of the Sourisseau Academy.)

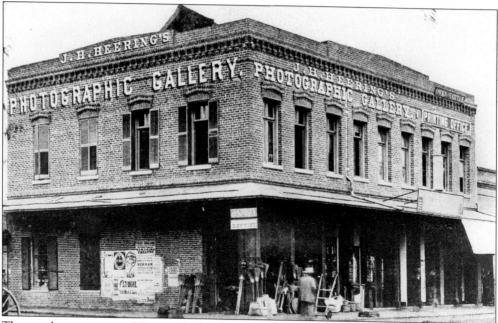

The northwest corner of First and El Dorado (now Post) Streets was home to the *San Jose Mercury* newspaper in the late 1860s. At that time, the *Mercury* staff consisted of editor James Jerome Owen and printer Benjamin Hinckley Cottle. Photographer John H. Heering also occupied the building. Heering may be credited for some, if not all, of the early images of downtown included in this collection.

This structure at the northwest corner of Market and Santa Clara Streets was probably the first multi-story building in San Jose. It was built as the Masonic and Odd Fellows building in 1865, although these two fraternal orders left shortly after the building was damaged in the earthquake of 1868. It was repaired and renamed the Hensley Block in honor of one of the building's investors, Major Samuel J. Hensley.

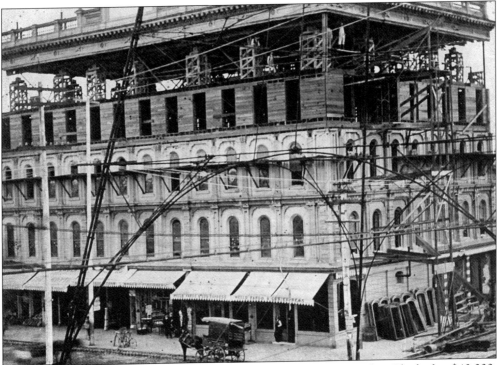

In 1880 wealthy Gilroy farmer Thomas Rea purchased the Hensley Block for $40,000, renaming it the Rea Building. Near the turn of the century Rea decided to raise the roof—literally. He expanded the building by adding a fourth and fifth story as can be seen in this photograph, taken through the framework of the Electric Light Tower.

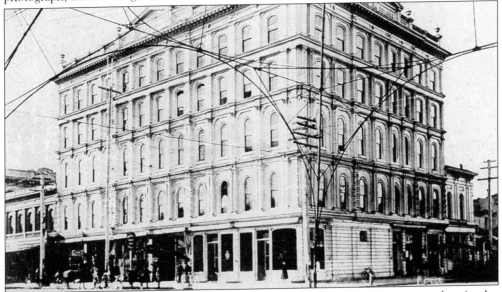

After the Rea Building expansion was completed, Growers Bank of San Jose acquired it. Anglo-California National Bank later bought the building and demolished it in 1941. A two-story, concrete building designed in late art deco style by local architect Ralph Wycoff was built in its place. It is now the headquarters of the San Jose National Bank.

Two

BANKS, BUSINESSES, AND BUILDING DOWNTOWN

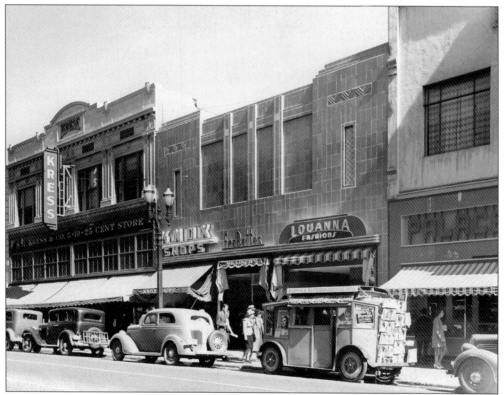

Downtown was still the place to shop in 1940 San Jose. S.H. Kress's 5-10-25 Cent Store, Knox Shops, FreBettes Millinery Shop, and Louanna Fashions were all busy shops inhabiting an odd architectural mix from different eras on the east side of South First Street's 100 block. All are now gone and their spaces are taken up by the Pavilion Shops.

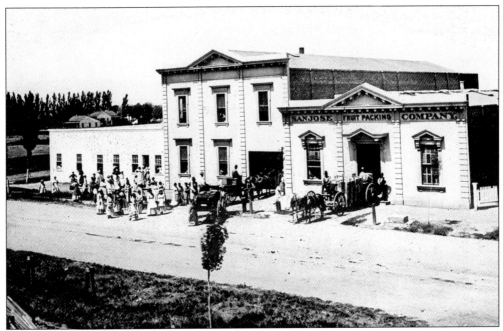

San Jose Fruit Packing Company stood on the southeast corner of Fifth and Julian Streets from 1876 until the early 1890s. The Fruit Packing Company began as a humble operation run by Dr. James Madison Dawson and his wife from a small shed on their property on The Alameda, which made it the first cannery in Santa Clara County. This photograph was taken when it opened at its new location. Not long after, the cannery began shipping fruit all over the nation.

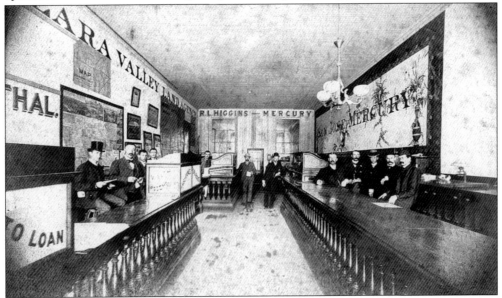

When this photograph was taken in 1890, the San Jose Mercury Publishing and Bookbinding Company shared this somewhat sparse office with the Santa Clara Valley Land Agency. They were located in the Lyndon Block on the north side of Santa Clara Street, just east of what is now Almaden Avenue. The two businesses shared space only briefly. By 1893 the Land Agency was out of business.

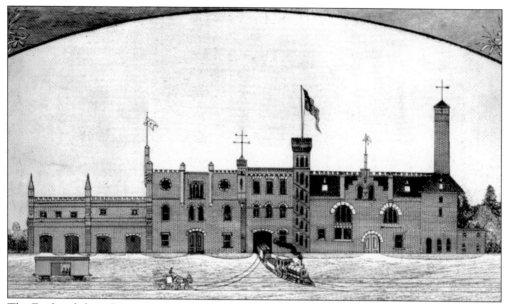

The Fredericksburg Brewery on West Julian near The Alameda was the largest of the half-dozen breweries that once existed in San Jose. Established in 1869 by German brewer Gottfried Krahenberg, Fredericksburg eventually expanded into a large fortress-like structure, which housed not only the brewhouse but also a saloon and hotel. The brewery even had its own railroad spur line connecting to the main Southern Pacific line a half mile away.

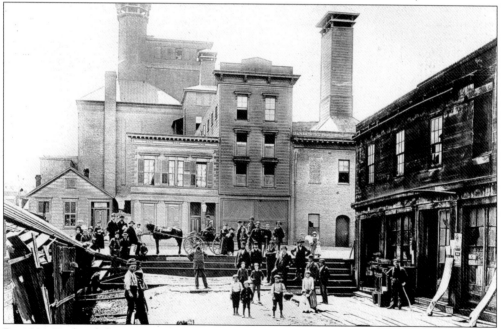

By 1890 Fredericksburg employed 120 men, women, and children. Forced to close in 1919 when Prohibition became law, Fredericksburg was reopened in 1933 after repeal. In 1952 it was purchased by Falstaff Brewing Company, but was too small to satisfy the demand for Falstaff beer. Production moved to a larger facility in San Francisco and the building was demolished in 1980. (Courtesy of San Jose State University Special Collections)

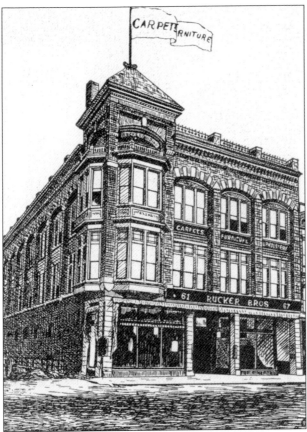

Twin brothers Samuel and James Rucker began a carpet sales business in 1886 in downtown San Jose that prospered quickly. Four years later they built the three-story Rucker Building at 61-67 North First Street and expanded their business to include quality furniture. That same year, 1890, Sam (a former member of the state legislature) became mayor of San Jose. Another brother, Joseph, had just taken over his father's successful real estate and insurance business down the street.

But the Rucker brothers' partnership in furniture sales was over by 1897, and in 1901 Sam joined forces with Alfred Madsen, reopening the business as the Rucker-Madsen Furniture Company. The partnership lasted just five years but the Madsen Furniture Company continued on successfully until Al's retirement in 1925.

Joseph Rucker Samuel Rucker

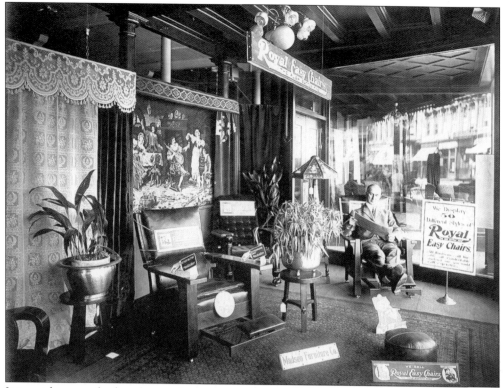

It is not known whether the gentleman posing here *c.*1912 in the easy chair is Al himself. The Madsen saleslady is demonstrating the innovative "parlor bed" a precursor of today's sofa bed. Although the Ruckers are long gone, Joseph's lovely Queen Anne-style home still stands at 418 South Third Street, and is a San Jose historic landmark.

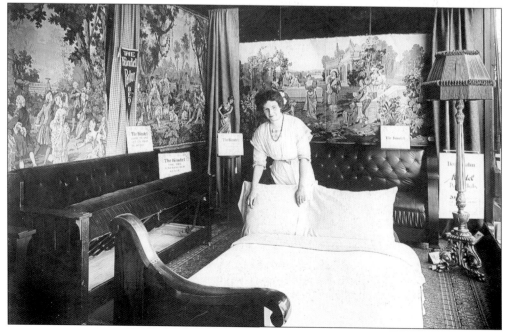

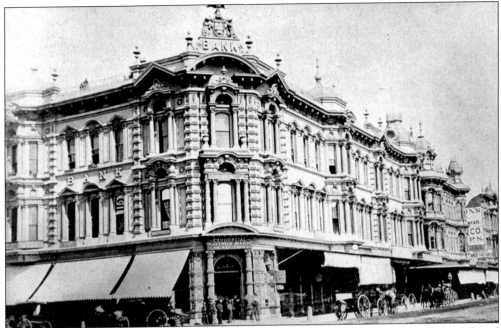

The Commercial and Savings Bank was San Jose's third bank, organized in 1869 by Edward McLaughlin and C.T. Ryland. In 1872 they erected this ornate building at the northwest corner of First and Santa Clara Streets. In 1883 it became home to the San Jose Safe Deposit Bank. Bank of Italy acquired the building in 1925 and demolished it in order to build the landmark Bank of Italy tower.

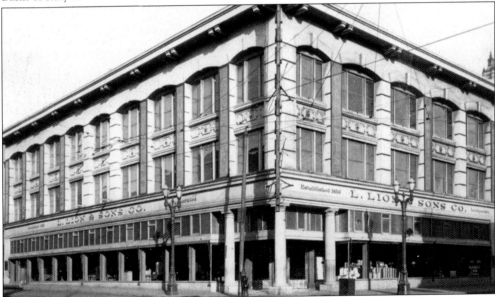

In 1856 Lazard Lion opened the first furniture store west of Denver. Originally located at the corner of Santa Clara and San Pedro Streets, L. Lion and Sons moved to this new building located at Second and San Fernando Streets in 1908. The store eventually expanded to five levels, becoming the largest furniture store in San Jose. The company ceased operations in 1967 after 109 years of family-owned management. (Courtesy of the Sourisseau Academy.)

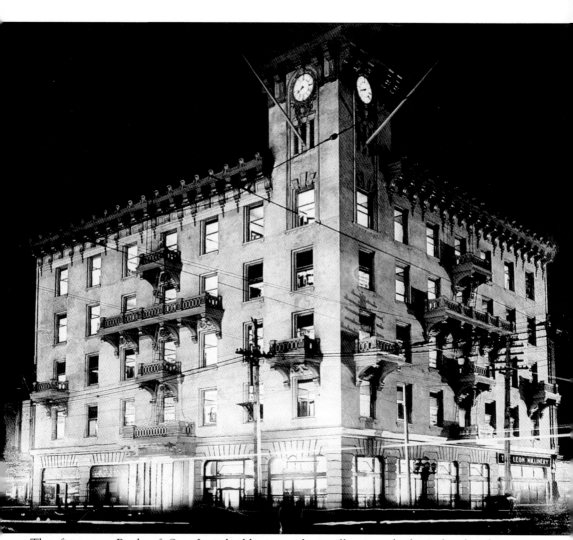

The five-story Bank of San Jose building stands in illuminated glory shortly after its construction at the northeast corner of First and Santa Clara Streets. The Bank of San Jose was the city's first bank, founded in 1866 by Dr. William J. Knox and Thomas Ellard Beans. This reinforced concrete structure replaced its three-story predecessor, built on this site in 1872 but destroyed in the 1906 earthquake. The four-faced clock tower served as the community's main timepiece for many years. The clock was high enough to be seen throughout downtown and the deep tolling of its 2000-pound bell could be heard even further. But a fine clock does not ensure a bank's survival and in 1927 the Bank of America acquired the Bank of San Jose. Renamed the Beans Building, it housed various offices until its demolition in January 1947. Old timers who wish to hear the tolling of the tower clock once more can do so at Glendale Galleria in southern California, where the old clock keeps time for mall shoppers.

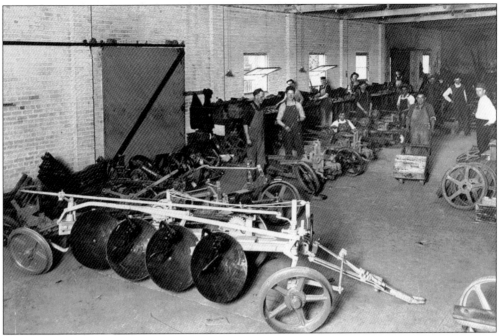

For many years agriculture was the primary industry in Santa Clara County. Downtown San Jose had its share of businesses that directly served the farming community. One such business was the Knapp Plow Company. The founder of the firm, Robert L. Knapp, developed the special hillside plow seen in the foreground. This plow allowed vineyards to be planted on steep slopes such as those found in the Santa Cruz Mountains.

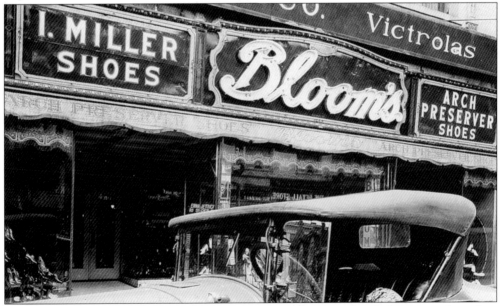

In 1867 Polish native Meyer Bloom came to San Jose. He opened a clothing store first, then converted it to a shoe store in 1904. In 1913 the store was moved to this location at 135 South First Street. Bloom's Shoes remained a downtown family-owned business until son Max Bloom retired and sold it in 1965. The Knight Ridder building now occupies this site.

Next door to Bloom's Shoes was the local branch of Sherman, Clay & Company. Founded in San Francisco in 1870, Sherman, Clay sold pianos, victrolas, band and string instruments, organs, records, radios, and sheet music. Sherman, Clay stayed in this location until 1931 when it moved to the 200 block of South First Street. (Courtesy of San Jose State University Special Collections.)

In 1927 Clyde Arbuckle, then 24 years old, purchased a four-string Bacon plectrum banjo from Sherman, Clay for the princely sum of $270. Clyde played banjo professionally for several years, but a career in music was not to be his true calling. His interest turned to California and local history. As the years passed Mr. Arbuckle, half brother of famed movie star Fatty Arbuckle, became recognized as the leading expert on the history of San Jose and Santa Clara County.

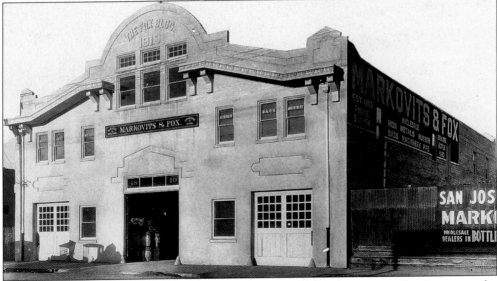

Markovits and Fox had operated a successful scrap and salvage company in San Jose since the late 19th century. In 1919 they erected this building at 40 North Fourth Street. Designed by local architect Louis Theodore Lenzen, it is a rare surviving example of Mission Revival industrial architecture. In March 2005 the building was demolished to make way for a parking garage for San Jose's new City Hall. (Courtesy of San Jose University Special Collections.)

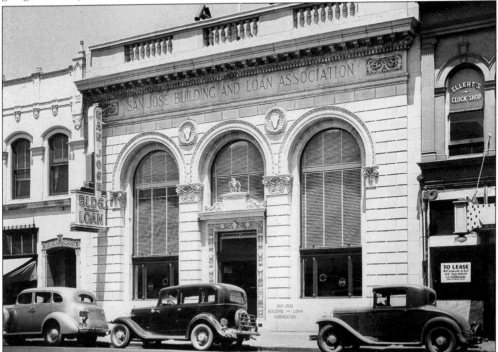

The lovely San Jose Building and Loan Association stands alone now on West Santa Clara Street near Market. Although currently vacant, it has served as home to a variety of financial institutions since it was built in 1927. The owner of the building offered it rent-free for the Bush-Cheney presidential campaign in 2000. This image was taken about 1940.

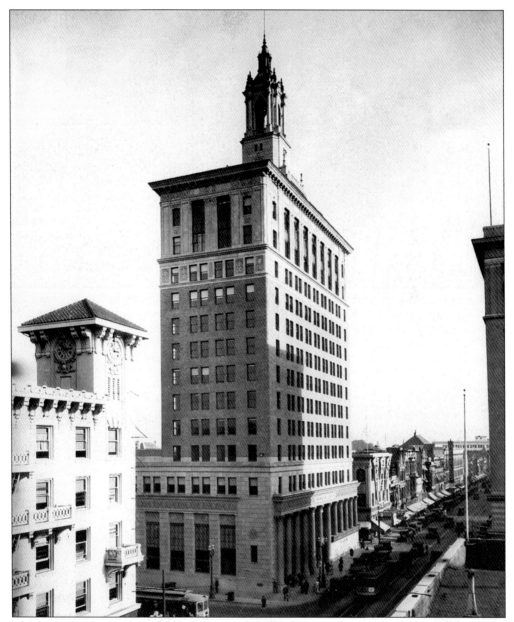

This is the Bank of Italy building at the time of its dedication in January 1927. It still stands on the southeast corner of First and Santa Clara Streets. Its founder, A.P. Giannini, was born in downtown San Jose in 1870. Though he moved to San Francisco and established the Bank of Italy there, the first branch was opened in his hometown of San Jose. Giannini brought revolutionary changes to the banking industry by combining his head for business with his heart for the common man. By employing ordinary members of the community and making it a point to assist even the smallest business owner with his bank loans, Giannini created an atmosphere of loyalty and confidence that enveloped employees and customers alike. In 1930, the Bank of Italy became the Bank of America, which to this day is one of the largest banking systems in the world. Despite being dwarfed by other modern structures, the Bank of Italy building remains a stately landmark in the downtown skyline.

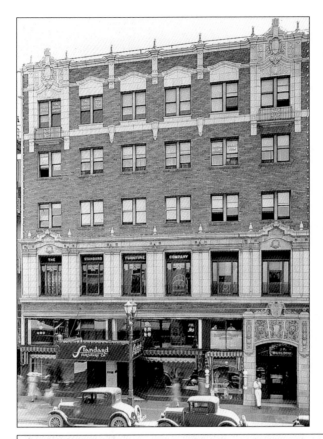

The delicately decorated Burrell building at 234 South First Street was considered one of the most modern office structures when it was built in 1927. Housing a variety of businesses, it was owned by F.L. Burrell, a native of Santa Clara County and a successful businessman. In addition to being vice president of the Food Machinery Corporation (FMC) he was also a director of the San Jose National Bank. The Federal building now stands on this spot. This image was taken about 1930.

Picchetti Brothers moved their automobile business from 400 South First Street to this larger building in the late 1920s. It was located at 425 South Market Street between Viola and Balbach. In addition to auto repair and accessories, Picchetti Brothers sold Nash cars, Ajax cars, and Federal trucks, models that have long since disappeared from the automobile marketplace.

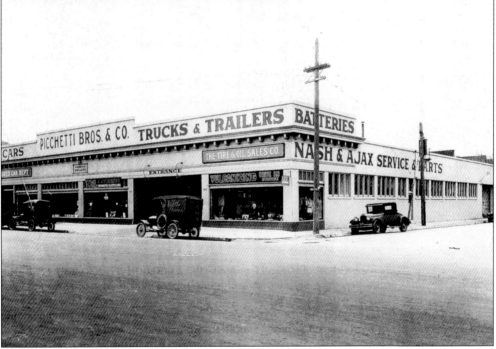

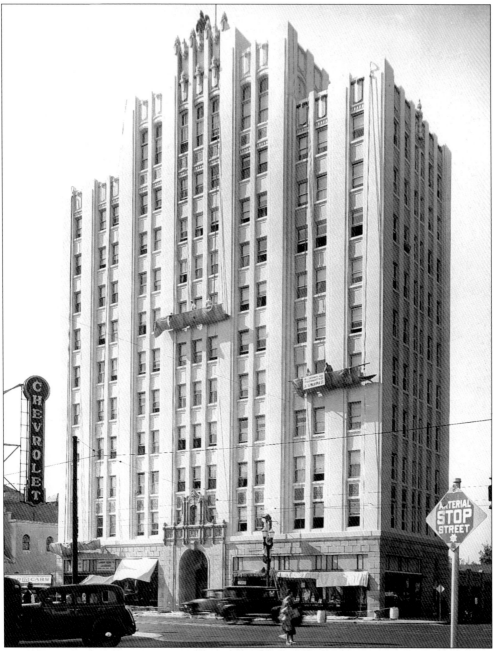

San Jose's most impressive art deco structure is the Medico-Dental building, located on East Santa Clara at Sixth Street. It was built in 1928 by a group of medical professionals who wanted to consolidate local medical services into one convenient location. The Medico-Dental building was one of four skyscrapers built in San Jose during the 1920s building boom. It stood 11 stories high with a roof garden, public ballroom, two story parking garage and full service gasoline station. Architect William Weeks gave it dramatic soaring lines leading to a ziggurat-inspired roof. Now called Vintage Tower, it was converted into apartments in the late 1980s. (Courtesy of San Jose State University Special Collections.)

Oliver Ambrose Hale came to San Jose in 1876. He and his father opened a small general store at 140 South First Street in San Jose. Their motto was "Good goods, good service, and good prices." With the help of his four brothers he established a chain of Hale Brothers stores from Petaluma south to San Diego. In 1950 Hale Brothers merged with Broadway stores to form the Broadway-Hale Company.

In March 1931 Hale Brothers opened a new flagship department store at the southeast corner of First and San Carlos Streets. Hundreds attended the grand opening that featured a dedication speech by California governor James Rolph. The letters "KPO" at the top of the sign refer to San Francisco radio station KPO that was jointly owned by Hale Brothers and the *San Francisco Chronicle*. (Courtesy of San Jose State University Special Collections.)

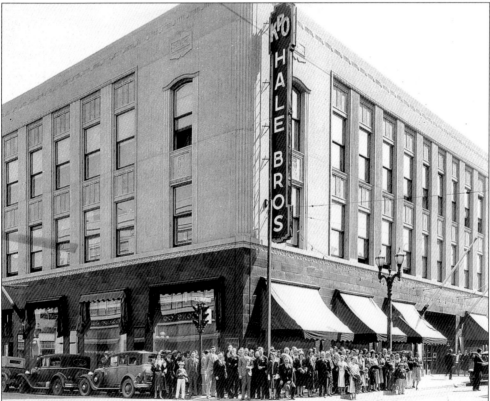

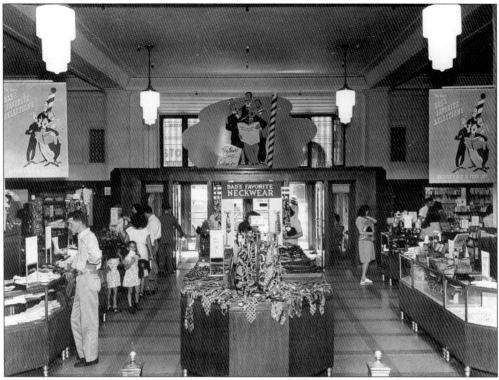

This Father's Day sale at Hale featured a table full of neckties of questionable taste. The downtown store was the last Hale store when it was closed in February 1968. Although the decline of downtown San Jose was certainly a factor, it was rumored that Broadway-Hale was closing their Bay Area stores in favor of Emporium, a company in which they had a considerable financial investment. (Courtesy of San Jose State University Special Collections.)

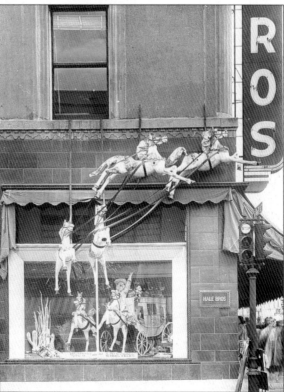

An example of Hale Brothers' innovative use of display windows features a California Santa driving his Christmas stagecoach through the store window. (Courtesy of San Jose State University Special Collections.)

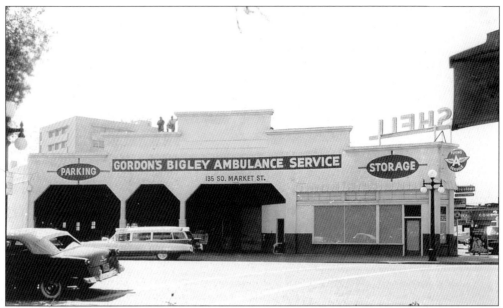

In 1926 Charlie Bigley founded the first motorized ambulance company in San Jose. At that time drivers were paid on commission, which often resulted in ambulance drivers racing each other through city streets to be first on the scene. This photo was taken in the early 1960s from the northern end of Plaza de Cesar Chavez. The Wells Fargo building in Park Center Plaza now stands on this spot.

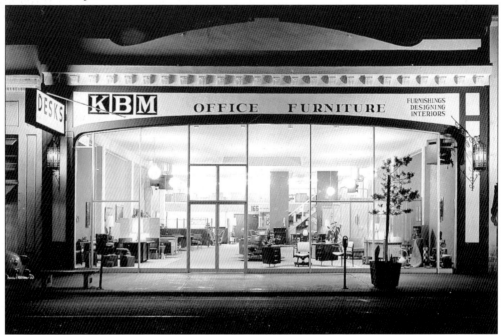

The latest in modern office interiors was on display in the brightly lit KBM Office Furniture store shortly after they opened at 166 South Second Street in 1962. They closed their doors and moved to East Junction Avenue in 1977. The original building space is now the open area between the San Jose Repertory Theatre and Hawg's Seafood Restaurant, facing Second Street.

34

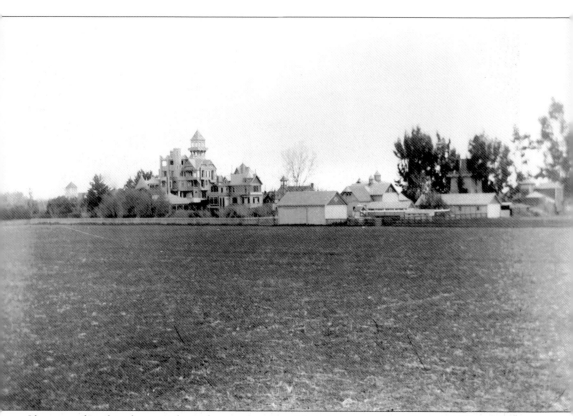

If you stood in this photographer's shoes today you might get run over by a distracted driver on his way to Santana Row or Valley Fair Shopping Center. When this image was taken around 1900, Sarah Winchester's bucolic farmland stretched out around her imposing mansion, covering 160 acres. The seven-storied building was reduced to four following the 1906 quake, and the estate now covers a mere four acres. When Mrs. Winchester died in 1922, the home became a tourist attraction, and the land around it was gradually developed. Yet it wasn't until the 1950s when Valley Fair was built nearby that development in outlying areas became a measurable threat to downtown business. By the 1960s the exodus out of downtown San Jose was mirrored in cities all over the country, as suburban neighborhoods created their own burgeoning business districts. Though downtown is once again becoming an attractive place to live and work with fine restaurants and entertainment, for a nice pair of shoes one still has to go elsewhere.

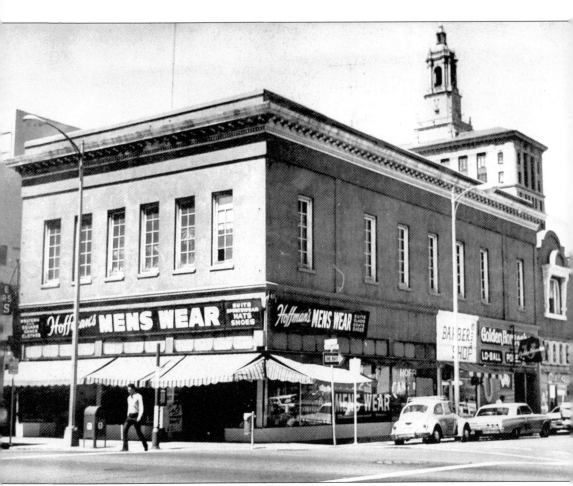

This innocuous-looking building was the cause of much legal wrangling and hand wringing among local historians in the mid-1970s. Known as the Murphy Building, it was constructed in 1862 as one of the many properties of Martin Murphy Jr. Murphy came west with his family on the first wagon train over the Sierras in 1844. This particular property, located on the corner of Market and Post (formerly El Dorado) Streets, served as the county courthouse from 1863 to 1868. Preservationists used this fact as an argument to save it from the wrecking ball that would raze it to make way for the Crocker Financial Plaza. The city council and local historians were at odds. But while a decision about whether to demolish the building was pending a demolition permit was mistakenly issued by a San Jose building inspector, and on January 12, 1976, a large part of the building was destroyed. Costs to repair the damaged structure were considered prohibitive, so the site was subsequently leveled in early March.

In order to make the vision of Park Center Plaza a reality, several blocks of homes had to be cleared in 1962. Rather than attaching meaningful names to these remnants of old San Jose, this particular house was identified simply as, "Parcel 21, Block 445." It was used for training and practice by local firefighters, although saving the house was certainly not their intent.

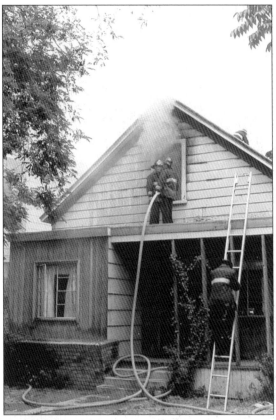

By 1969 the land was cleared and construction of Park Center Plaza was well underway. This is a view looking northeast from Park Avenue, as the foundation is set for the Bank of America. That same year, Mike Mitchell of Holmes Properties said, "From the standpoint of the property owner, we have finally experienced the long-awaited breakthrough in downtown San Jose—and a full-scale building boom is on. Within two years, you won't recognize this city."

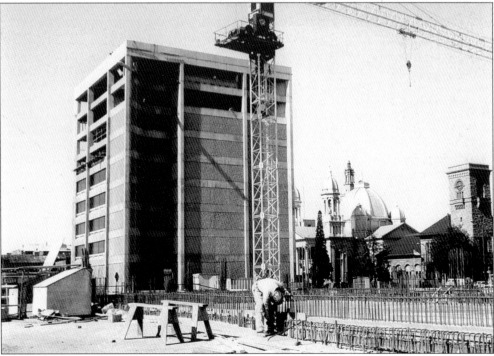

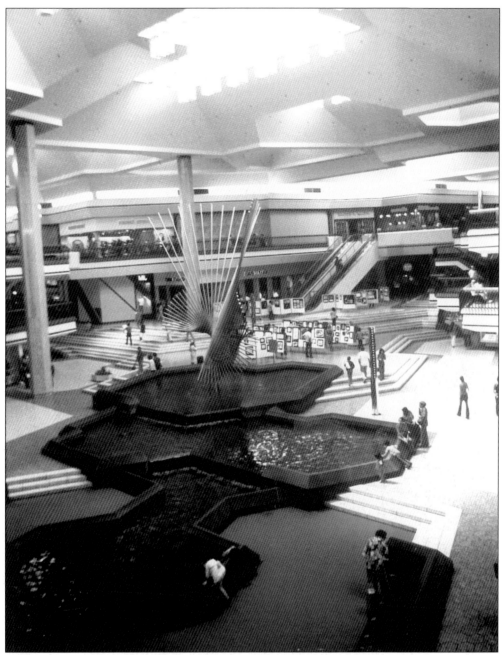

When it opened in 1971, Eastridge Shopping Center was considered the largest enclosed shopping mall on the West Coast. With 1.7 million square feet of retail shopping space, the center and its 150 stores was touted by developers as "a veritable downtown." The mall did generate enormous interest, and the drain away from downtown businesses, already in decline, was harshly felt. This photo was taken *c.* 1975.

Three

THE SEAT
OF GOVERNMENT

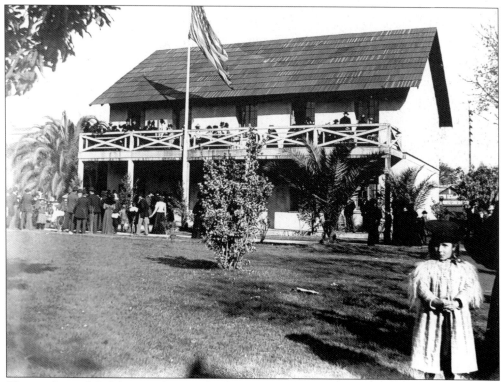

This replica of California's first statehouse was built in 1899 to commemorate the 50th anniversary of the California State Legislature. San Jose had served as California's first state capital from 1849 to 1851, but rainy weather and the promise of a grander statehouse prompted the legislature to move the capital to Vallejo. The replica was built in Plaza de Cesar Chavez across the street from the site of the original statehouse.

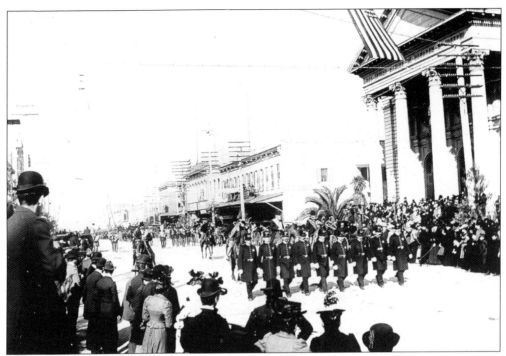

The cool December weather did not bother these smartly dressed San Jose police officers marching in the California Jubilee Parade. The parade was held December 21, 1899, to celebrate the first meeting of the California State Legislature fifty years earlier in San Jose. The marchers are heading south on Market Street and have just passed the entrance to Saint Joseph's Church.

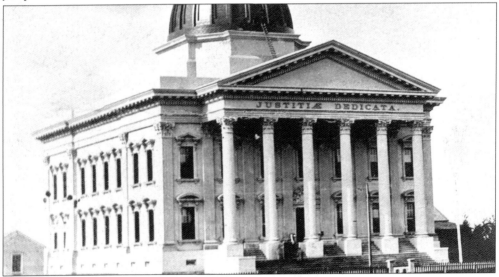

Santa Clara County's imposing new courthouse stands alone in this photograph, taken a year after its completion in December 1867. A single great courtroom occupied the space beneath the 115-foot-high dome. The Renaissance Revival building was designed by local architect Levi Goodrich and built at a cost of $200,000. But the grand edifice did not lure the state legislature back to San Jose as many locals had hoped.

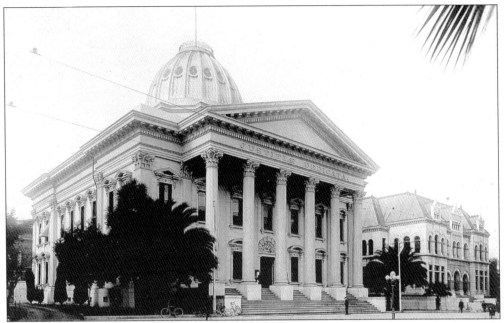

The Santa Clara County Courthouse is pictured here around 1895. By this time the one great courtroom had been divided into three smaller courtrooms. To the right stands the Romanesque Revival–style Hall of Records that was connected by passageway to the courthouse. The Hall of Records was demolished in 1962.

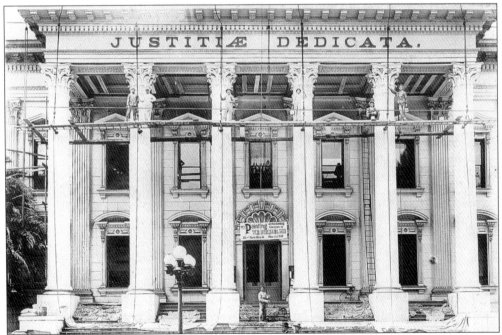

Scaffolding hangs in front the Santa Clara Courthouse as San Jose paint contractor W.M. Herman and son apply a new coat of paint in 1912. One of the fearless painters, Lee Jensen (third from the right on the scaffold), climbed and painted the 70-foot flagpole that stood on top of the 115-foot courthouse dome.

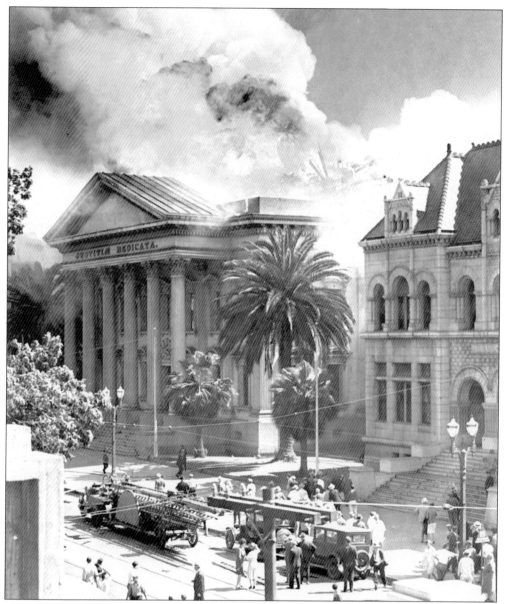

One of the most spectacular fires in the history of San Jose occurred on May 18, 1931, when the Santa Clara County Courthouse caught fire. The fire started on the upper floor and quickly spread throughout the building. All San Jose firemen, on duty or off, responded to the blaze, but were unable to effectively fight the fire because their ladders were too short and their water pumpers too weak to reach the roof. This photo was taken at about 3 p.m. as the great dome collapsed into the interior "with a roar heard for miles." Although the courthouse was gutted, hardworking firefighters saved the surrounding buildings, including the adjacent Hall of Records. Despite the severity of the blaze, injuries were minor. A year later the courthouse was rebuilt with an additional third floor. But the great dome was never replaced, leaving the courthouse with an unfinished look. As a final touch, the lofty legal motto on the front façade, "Justitia Dedicata" was replaced with the more mundane "Santa Clara County Court House." (Courtesy of the Sourisseau Academy.)

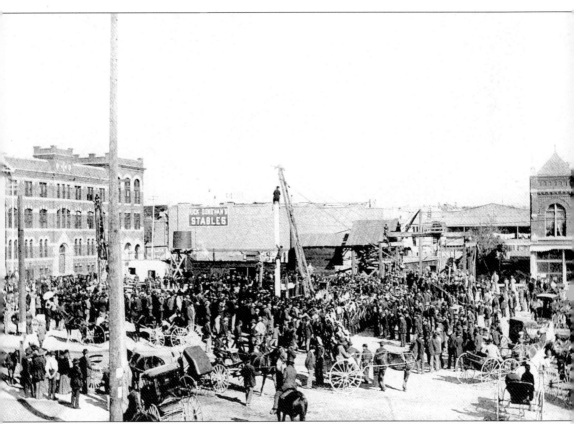

This crowd is gathered to witness the cornerstone being laid for San Jose's post office building on the corner of San Fernando and Market Streets in November 1892. The Romanesque-style post office was a lovely addition to downtown when it was completed in 1895 and is now an historic landmark. Made of high quality sandstone from the Levi Goodrich quarry in Almaden, it was built by the same Italian stonemasons who created the quadrangle at Stanford University.

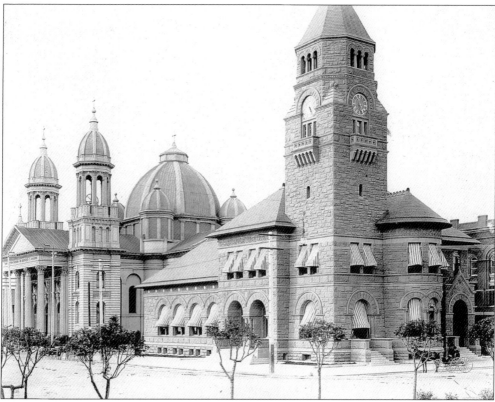

Post office architect Willoughby Edbrooke constructed a virtual fortress with walls and floors 3 to 4 feet thick, set upon a concrete foundation imbedded with steel pillars. The architect may have shown some seismic foresight by balking at the notion of building a bell tower—but he was overruled. Thus this image shows the original clock and tower that stood for less than a dozen years before it toppled in the Great Quake of 1906.

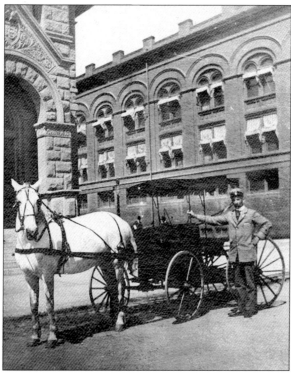

Mail carrier Gerhardus DeWit provided efficient delivery service from his horse-drawn transport in 1900. The post office entrance is visible to the left. DeWit was one of the first mail carriers in San Jose when home delivery service began in 1884.

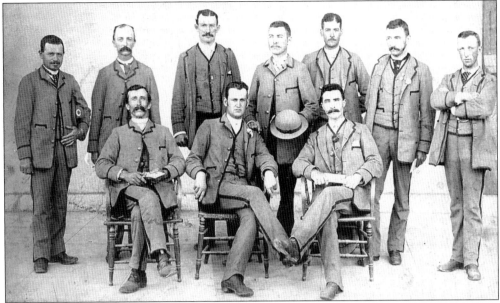

San Jose's letter carriers gathered for a formal photo around 1900. Gerhardus DeWit, seated on the left, is also pictured with his horse and buggy in the previous photograph.

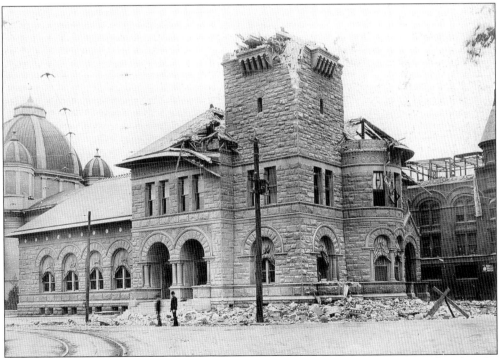

While the post office building appears to be heavily damaged from the 1906 earthquake, the rubble in the street is due largely to the collapse of the clock tower and part of the roof. The rest of the building was mostly unscathed.

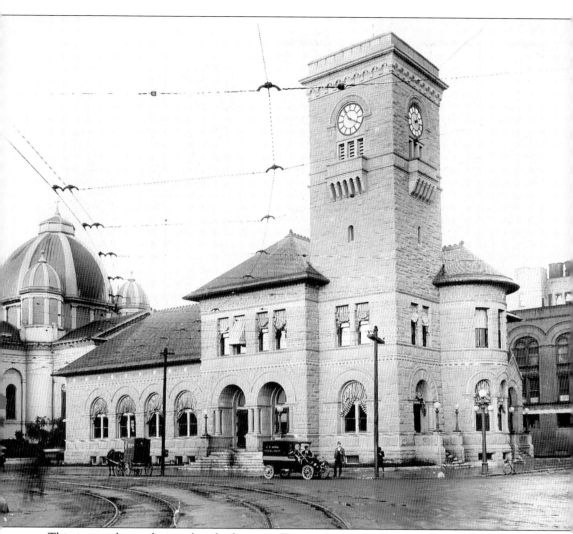

This image shows the newly rebuilt post office roof and clock tower about 1910. In 1908, Danish immigrant Nels Johnson was commissioned to install one of his "Century Tower Clocks"—clocks built to last a century—for the rebuilt post office. As of this writing, it is one of only two in the United States (the other is in Manistee County, Michigan) that is still operating as Mr. Johnson designed it. Someone must rewind the clock every week or so. All other Century Tower Clocks in the country have been converted to electrical operation. As San Jose's clock nears it's century mark and shows no sign of mechanical difficulties, we can tip our hats to Nels Johnson and his guarantee.

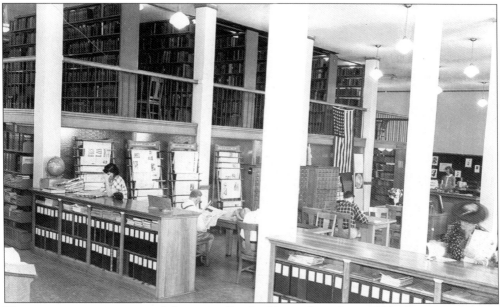

This is a rare interior view of the post office building taken about 1950, during the years it served as the San Jose Public Library. By 1933, San Jose had outgrown its picturesque post office and a new one had been built facing St. James Park. The old post office then became the public library. The glass partitions are one of the few remnants, though these were later removed because too much hanky panky went on in the book stacks behind them!

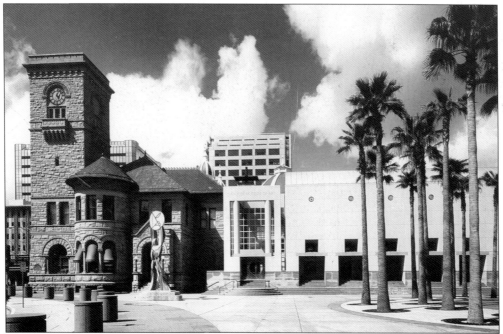

The library eventually moved to larger quarters in 1970, at which time the building was gutted and reinvented once again as the San Jose Museum of Art. Now in its third incarnation, the post office building grew an architecturally incongruous 45,000 square foot addition in 1991 to provide proper space for the art collection. (Courtesy of Pat Kirk.)

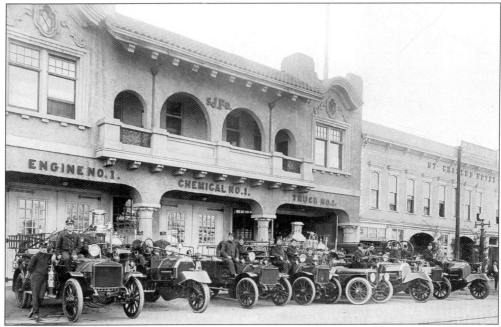

Pride must have mixed with nostalgia when this group of San Jose firefighters was photographed about 1916. The last of the horse-drawn fire apparatus had been eliminated and firefighters posed with their fleet of all-motorized vehicles. Note that several of the steamers are pulled by three-wheeled Knox-Martin tractors. This is the Market Street fire station designed by Wolfe and McKenzie, built in 1908, and demolished in 1951.

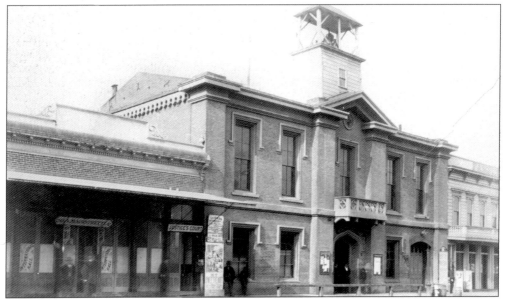

The first San Jose City Hall stood at 35 North Market Street, between Santa Clara and St. John. Built in 1855, its original, whimsical architectural design resembled a medieval castle, complete with roof parapet. In 1870 it received this staid renovation. Following the move to the new city hall in 1889, this structure was retrofitted to serve as Engine No. 2 of the city fire department. (Courtesy of the Sourisseau Academy.)

48

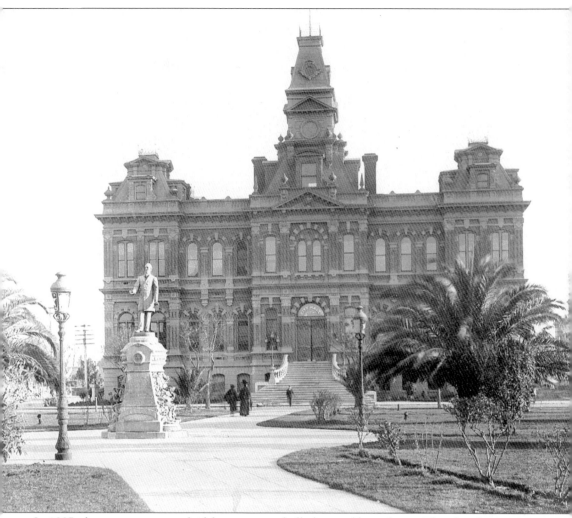

In 1887, the cornerstone was laid for a new city hall, designed by architect Theodore Lenzen to serve San Jose's growing population of 17,000 citizens. Placed in the center of today's Plaza de Cesar Chavez, it was modeled after a Bavarian town hall of the mid-Victorian era. It housed city governmental offices as well as the library (on the second floor) and the jail (in the basement). Opened in 1889, it served the city for 69 years before a new city hall rose just north of downtown to replace it. Although a "Save City Hall" petition was circulated, the number of signatures fell far short of those needed. A small but vocal group had great sentimental attachment to the old building, even though local architects in 1958 deemed it, "a design reflecting a very bad period of German architecture." The city had outgrown the structure, it was in bad need of costly retrofitting, and there was no other practical use for it. So, in the summer of 1958, down it went. The fountain later built on this site was a way to commemorate the old building, although few are aware of that today.

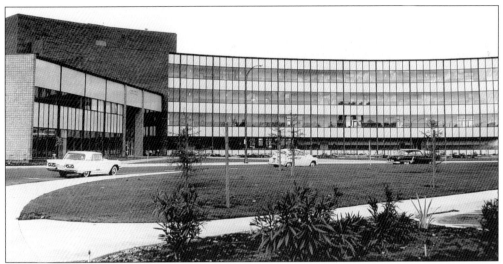

The next city hall was built of reinforced concrete with a curved wall of glass and steel. It was a thoroughly modern structure in 1958 that cost $2.6 million and was designed to serve San Jose's growing community of 140,000 people. Built just north of downtown, its location was controversial, and many lobbied to return city hall to the center of town.

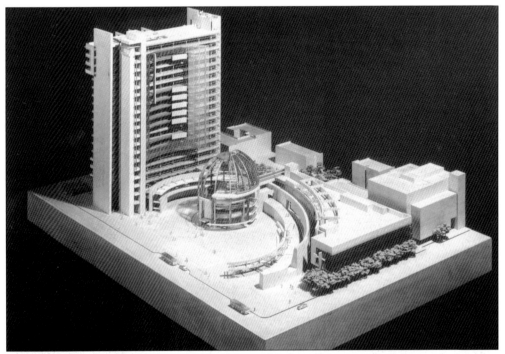

Slated to open in 2005, the new San Jose Civic Center will be a state-of-the-art facility that brings the seat of city government back downtown. Facing Santa Clara Street between Fourth and Sixth Streets, its 530,000 square feet includes a glass-domed public gallery. This ambitious project has also been controversial, due to concerns about the final cost of the project. (Courtesy of Richard Meier & Partners, Architects LLP; photographer Josh White.)

Four

SCHOOL DAYS

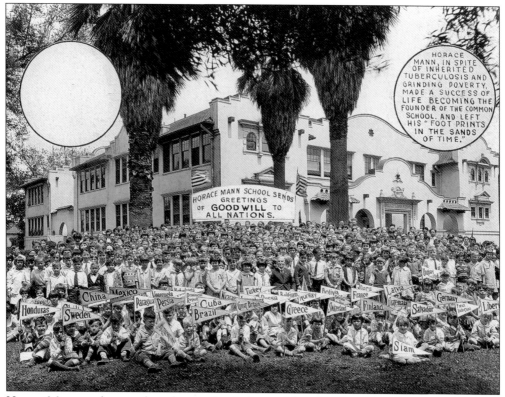

Horace Mann students and teachers gather in front of the school in the 1930s in celebration of international goodwill. (Courtesy of San Jose State University Special Collections.)

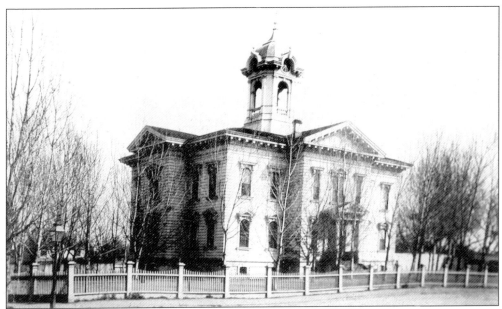

In the 1870s San Jose began building a new school in each of the city's four political divisions, or wards. This is the Fourth Ward School, built in 1874 at a cost of $18,000 and located at the southeast corner of Auzerais Avenue and Orchard Street (now Almaden Boulevard). Wards were often given nicknames and the Fourth was known as the "Bloody Fourth," probably referring to the rough neighborhood and the tough students who lived there.

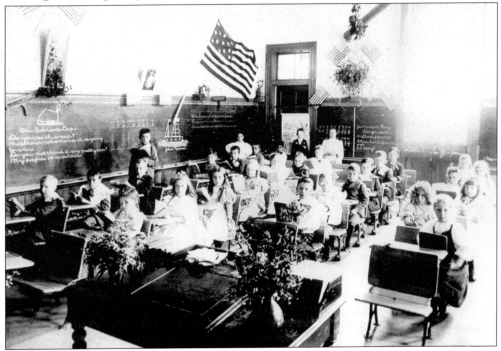

In 1892 the City Council decided the Ward schools needed more dignified names and the Fourth Ward School was renamed Lincoln School. This picture of the Lincoln School third grade classroom was taken in 1890.

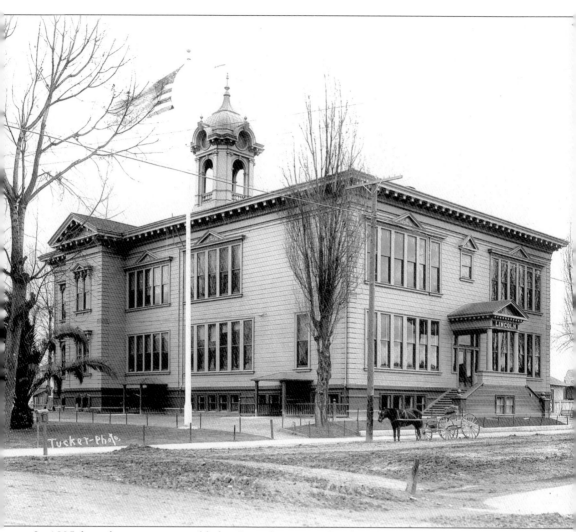

In 1895 four classrooms were added to Lincoln's original eight. Lincoln had the distinction of being the only one of San Jose's original 1870s wooden school buildings to survive the 1906 earthquake. It continued to function as a school until 1946 when the area's transition from a residential to a business district left too few pupils to justify keeping it open. The building served as school district offices and storage space until 1975, when it was torn down. The site is now part of the McEnery Convention Center.

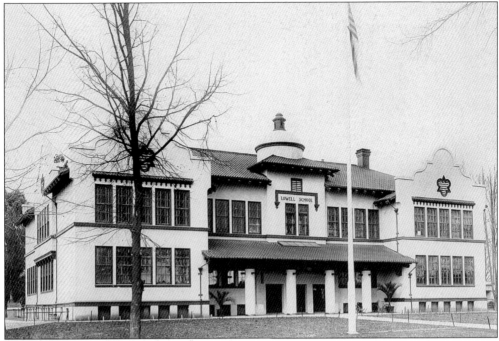

Lowell Elementary School stood at 275 Margaret Street between Sixth and Seventh Streets. Like the other school buildings erected in San Jose after the 1906 earthquake, it was built with thick stucco walls that were thought to be earthquake resistant. Years later an earthquake safety study concluded that while the stucco walls were sound, the heavy tile roof was in danger of collapse. This building was demolished in June 1971 and a new school constructed nearby.

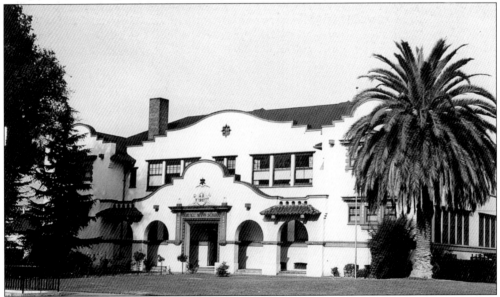

Horace Mann Elementary School, named after the 19th-century educator, stood on the north side of Santa Clara Street between Sixth and Seventh Streets. It was built in 1907, replacing a previous school of the same name that was badly damaged in the 1906 earthquake. This building was demolished in 1971 when it was unable to meet modern earthquake standards.

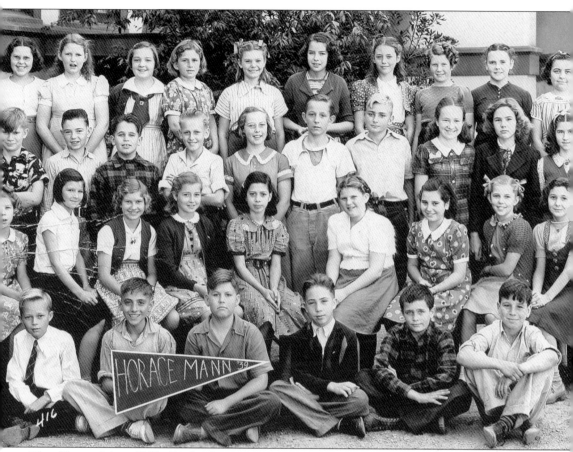

This Horace Mann Fifth Grade class picture was taken in June 1939. In 2003 a new $29.8 million Horace Mann School was opened, becoming the third school on this site since 1867.

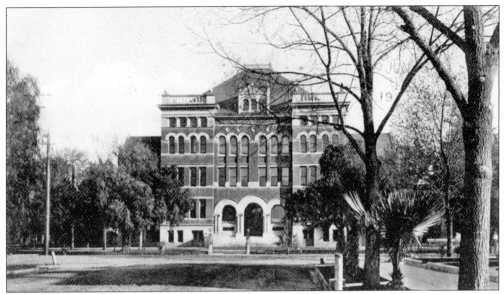

For many years high school students in San Jose had to share space with elementary school students at Horace Mann School. In 1898 the Board of Education built a spacious three-story high school at the southwest corner of Seventh and San Fernando Streets. Designed by local architect John Lenzen and built at a cost of $100,000, it was a local showplace proudly displayed to visitors.

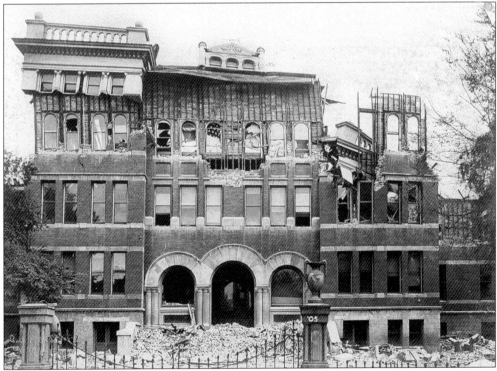

The new high school had been in use for less than eight years when the 1906 earthquake struck. The roof and walls collapsed, leaving the building in ruins. If the quake had hit later in the day when school was in session, the loss of life could have been catastrophic.

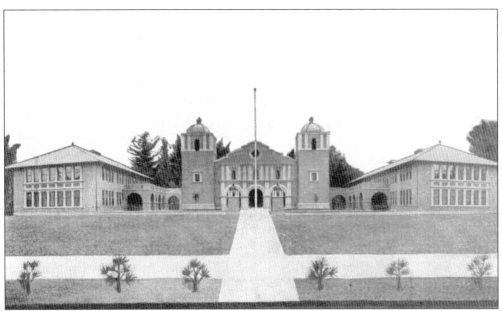

Six months after the earthquake the citizens of San Jose passed a $175,000 bond measure to build a new high school on the same site as the collapsed building. The new five-building campus was dedicated on September 9, 1908, and had a student enrollment of 786.

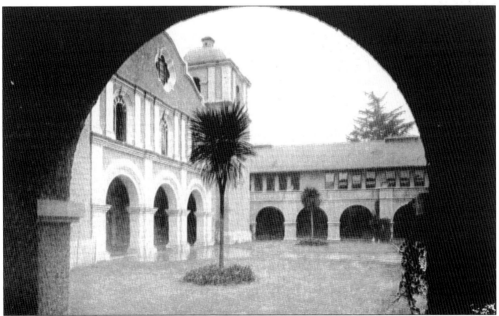

Inspired by the missions, this architectural style featured thick stucco walls, a red tile roof, covered walkways, cloisters, and a central auditorium flanked by two towers. The high school stood here until 1952 when the expanding student body of San Jose State College forced the school to move elsewhere for more space.

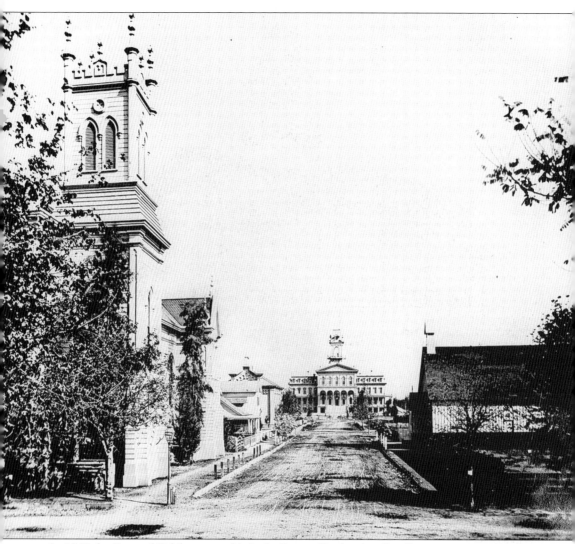

In 1862 the State of California established a "normal" school in San Francisco to train students to become elementary school teachers. In 1872 the normal school was moved to a new location on Washington Square in downtown San Jose. This 1876 photograph was taken at the intersection of South Second and San Antonio Streets. Looking eastward down San Antonio Street, we can see the main entrance to San Jose Normal School. On the near left is the First Baptist Church, while the smaller building on the right is the First Congregational Church. This section of San Antonio Street is now a pedestrian mall.

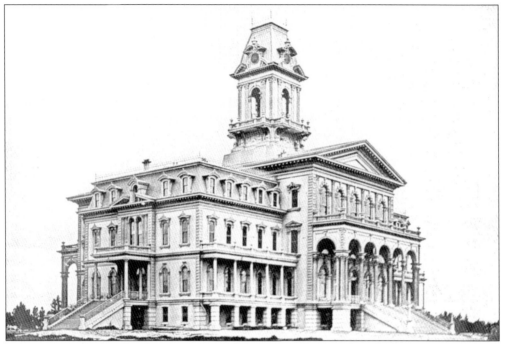

San Jose Normal School was a Second Empire–style, wooden building that included administrative offices, classrooms, library, museum, lecture hall, and recital hall. Built at a cost of $285,000, it was considered one of the most beautiful buildings in the state. But in the early morning of February 10, 1880 a fire broke out in the Normal School. The magnificent wooden structure burned fiercely and was totally destroyed.

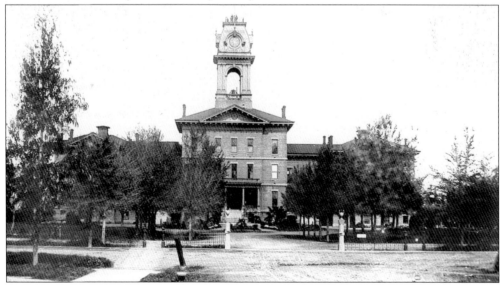

In 1881 construction was completed on a new Normal School building designed by local architect Levi Goodrich. To avoid the fiery fate of its predecessor, it was built with brick and stone and incorporated a 5,000-gallon water tank on the third floor. It appeared to have survived the 1906 earthquake with just a few fallen bricks, but a closer inspection revealed serious structural damage. The building was never reoccupied and was demolished in 1908.

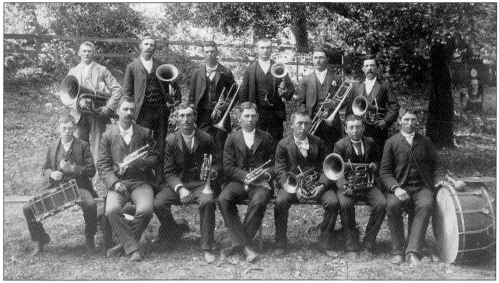

This Normal School Brass Band from the late 1880s appears to have recruited some older members from the community in order to fill out its ranks.

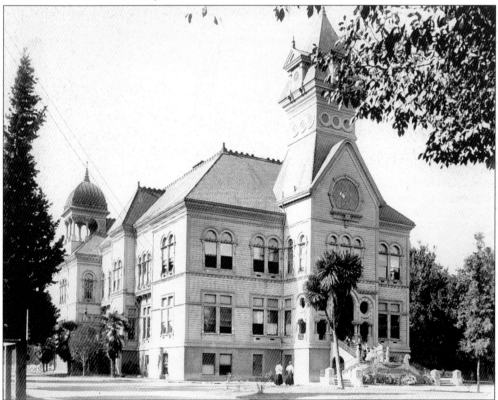

As part of their teacher training, Normal School students were required to undertake five months of supervised classroom instruction before graduation. Space to accomplish this was limited until 1892, when this Moorish Renaissance Revival-style training school building was constructed on the Normal School campus at the corner of Seventh and San Carlos Streets.

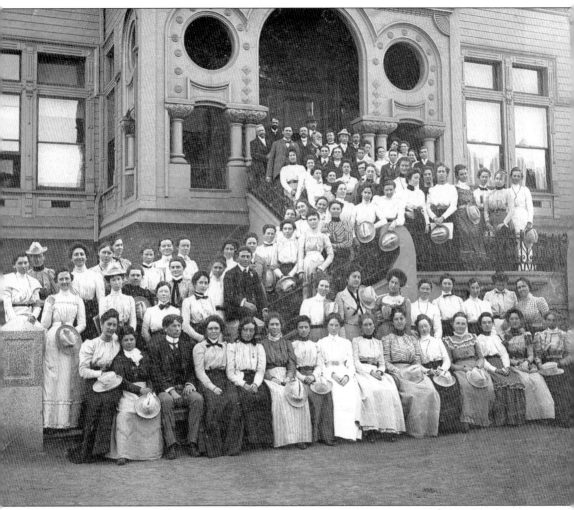

A graduating class of student teachers poses on the steps of the training school building near the turn of the century. In 1933 the training school building was pronounced a fire hazard and demolished.

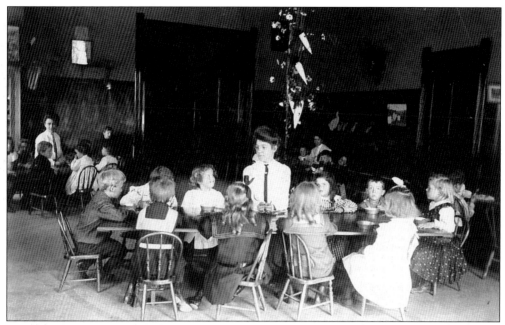

The training school was part of the San Jose city school system and provided an opportunity for student teachers to get real classroom experience. These Normal School students are teaching in one of the training school classrooms, c. 1903. (Courtesy of San Jose State University Special Collections.)

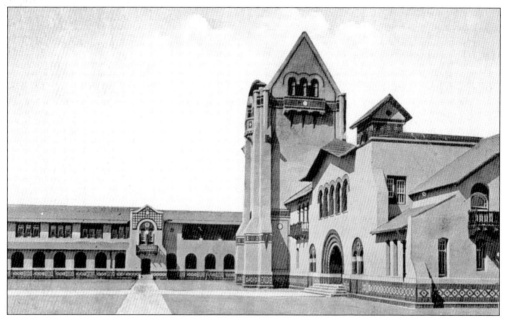

In 1907 the earthquake-damaged Normal School building was razed and its crushed bricks used in the foundations of the new campus. Inspired by the design at Stanford University, classrooms and administrative offices were built around a quadrangle. Construction was completed in August 1910 at a cost of $325,000. Of these buildings only Tower Hall and the adjoining auditorium remain. They are the oldest and most recognizable structures on campus.

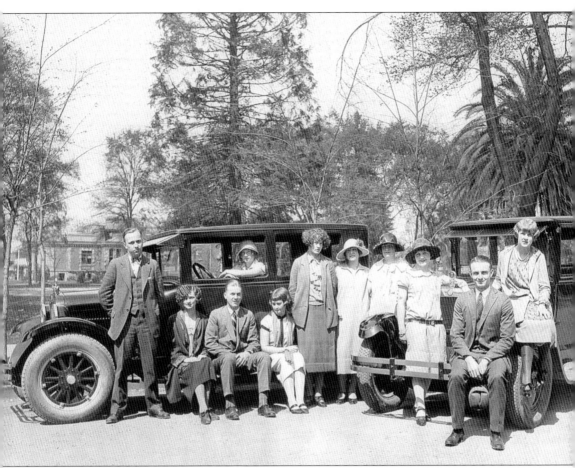

These San Jose State Teachers' College students seem ready to roll in their stylish automobiles, parked casually on Fourth Street, just south of San Fernando. The Carnegie Public Library is visible in the distance on the left. This image was taken in the early 1920s.

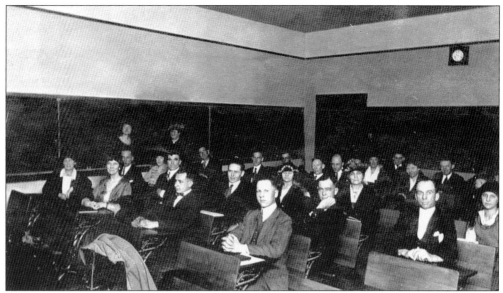

The San Jose Evening High School held its classes on the campus of San Jose High School from 1916 to 1952, though its name changed to San Jose Adult Center in about 1930. By the 1960s "branch" centers had opened at schools throughout the South Bay, and total enrollment topped 10,000. In 1967, the San Jose Adult Center became the Metropolitan Adult Education Program, as it is still known today. This image was taken in 1922.

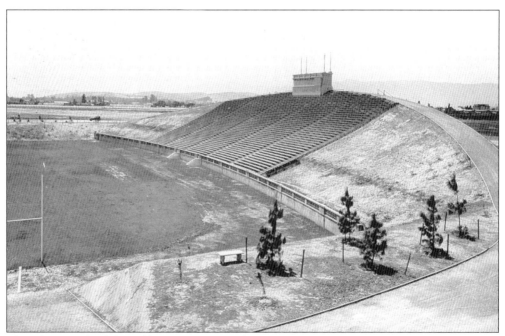

This photograph of the college's Spartan Stadium was taken shortly after it was built in 1933. It originally seated 4,000 spectators, but has been greatly expanded over the years to seat over 30,000.

Five

OUT AND ABOUT TOWN

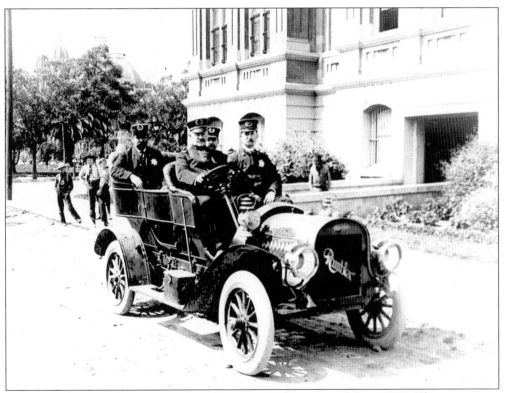

San Jose policemen demonstrate their department's first automobile *c.* 1907. The picture was taken just outside San Jose City Hall where the police department was located in the basement. The tunnel to the right leads under the building and out the other side and was used to transport prisoners to and from the city jail. Sitting next to the driver is John N. Black, who served as police chief from 1916 to 1944.

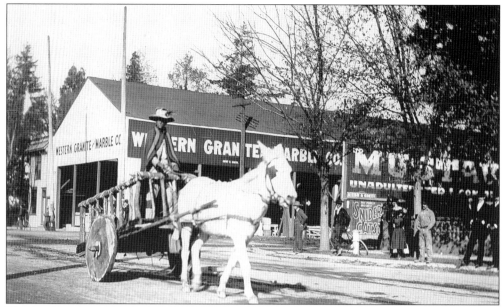

This participant in the 1899 California Jubilee parade is driving a *carreta*—an all-wooden cart that was the chief method of hauling heavy loads during California's Spanish and Mexican eras. Leather thongs held the cart together, while the wheels were sections sawn from tree trunks. In the background, at 370 North First Street, is Western Granite and Marble Company, which supplied much of the building stone used in San Jose.

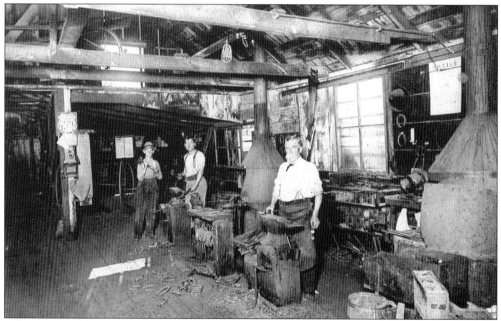

When this photograph of Carroll's San Jose Horseshoeing was taken in 1912, owner Tom Carroll (far right) was nearly 70 years old. He had been a San Jose blacksmith since 1880 and would soon retire from this shop at 45 South San Pedro Street. As automobiles, trucks, and tractors replaced horses, blacksmith shops disappeared from downtown San Jose. An era was passing.

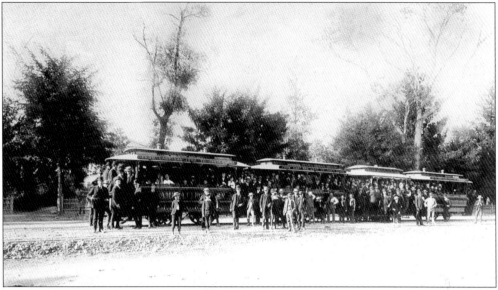

In 1888 an electrified railway powered by an underground third rail replaced the horse drawn trolleys along The Alameda. Equipment malfunctions and insufficient generating capacity often brought the new railway to a halt, as did pedestrians, who stuck their metal-tipped umbrellas into the slot carrying the third rail in order to see the sparks fly. Within two years the underground electric system had been torn out and replaced with one using overhead power lines.

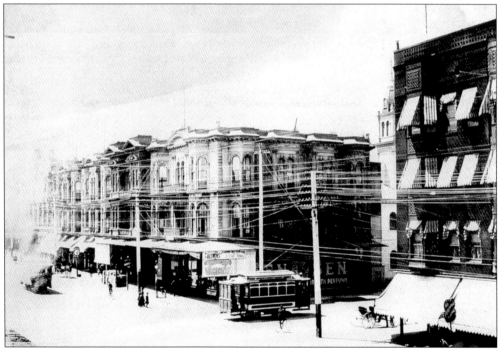

A San Jose Railroad streetcar heading south on Second Street prepares to cross Santa Clara Street *c.* 1905. This narrow gauge electric line ran from Second and St. John to Seventh and Keyes. The bicyclist passing the streetcar is one of many who had taken up cycling, causing a sharp drop in the revenue of local streetcar operators.

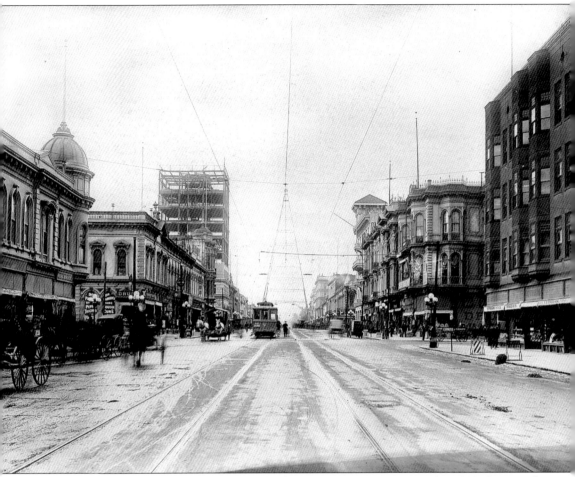

Horse-drawn vehicles constitute most of the downtown transportation in this 1910 photograph. The view is from East Santa Clara Street near Third Street, looking west toward the Electric Light Tower. In the center an electric trolley has stopped to load or unload passengers. On the left San Jose's second skyscraper, the First National Bank, is being constructed. The poles on the buildings lining the street are topped with incandescent lamps and are intended to augment the nighttime illumination from the Electric Light Tower.

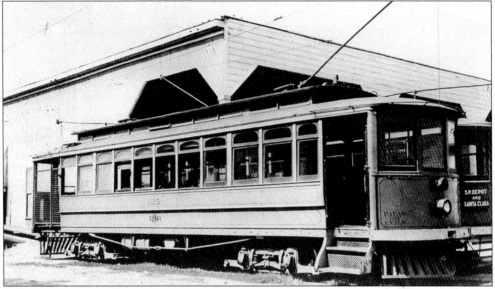

San Jose Railroad streetcar No. 125 sits outside the streetcar barn on West San Carlos Street. This 40-passenger trolley had been built in 1912 and later converted to one-person operation by removing the rear step and fencing in the back entrance. In 1938 the last streetcar line in the county was abandoned as buses replaced streetcars. It was also the end of the line for No. 125, which was probably scrapped shortly after this photograph was taken.

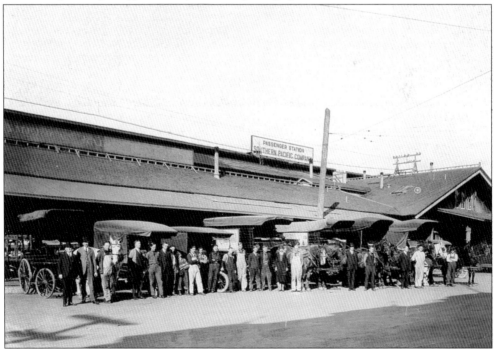

Employees of the American Railway Express pose with their delivery vehicles in front of the old Southern Pacific Railroad Depot at Market and Bassett Streets in San Jose. This depot was built in 1883 and expanded a number of times over the years. It ceased operations in December 1935 when the new Southern Pacific Depot on Cahill Street was opened.

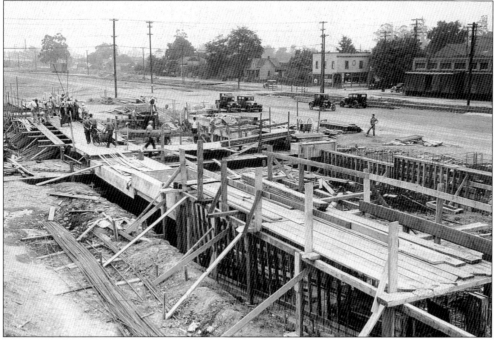

Work begins on the construction of the new Southern Pacific depot on Cahill Street in 1934. While the new station cost $100,000, Southern Pacific spent millions more on related construction such as new track, grade separations, and track realignment. It was one of the largest local railroad construction projects completed in the United States during the 1930s and gave a great boost to the local economy during the Depression.

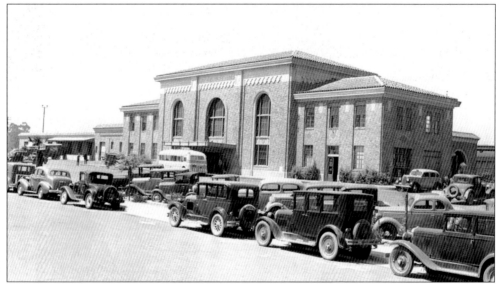

The new Southern Pacific Depot was dedicated on December 30, 1935. Architect J.H. Christie designed it in the Italian Renaissance Revival style, incorporating high ceilings, large windows, and interior murals into the building plan. It is still used as a railroad depot today, having been restored to its former glory by a $7.7 million renovation in the early 1990s. (Courtesy of the Sourisseau Academy.)

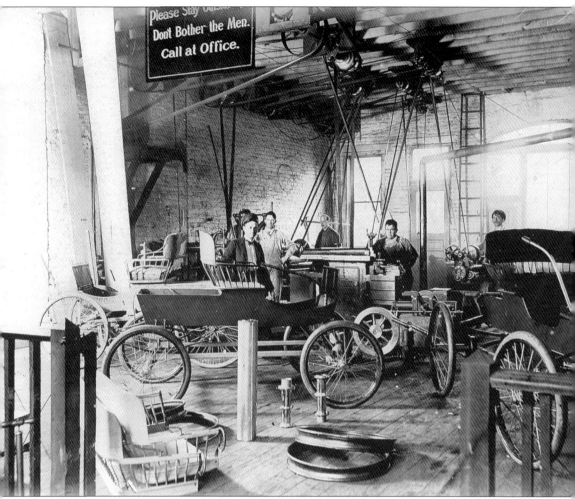

This interior view of the Osen and Hunt Automobile Factory shows William Hunt, wearing a motoring cap, and some of the staff at work c. 1900. George Osen and William Hunt made all automobile parts except engines, tires, and seats. The seats came from Hatman and Normandin's buggy factory, still doing business today as Normandin Chrysler–Jeep. Formerly a bicycle shop, this small factory stood at 69 South Second Street. While George Osen changed partners and moved to a larger facility in 1904, he was saved the additional heartache of seeing this space destroyed in the quake two years later. Mr. Osen, a savvy businessman who shifted with ease from bicycle sales to auto sales, had several partners and locations before Osen Motor Sales Company finally closed its doors on North First Street in 1944.

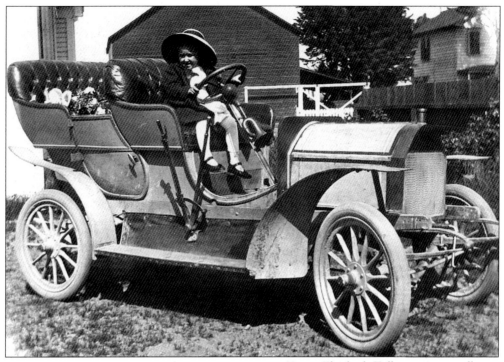

Young Elizabeth Talbot poses proudly behind the wheel of her family's Sunset automobile, the only automobile mass-produced in San Jose. The Victory Motor Company began producing the Sunset in San Jose after their original San Francisco factory was destroyed in the 1906 earthquake. The Sunset automobile factory at Martha and South First Streets manufactured cars until 1913.

By 1909 the Victory Motor Company was advertising that the new Sunset models were "guaranteed to make a mile a minute." The factory was turning out eight new cars a month and more than 230 Sunsets were registered in San Jose alone. But the Sunset never reached a market beyond the San Francisco Bay Area. By 1917 there were only 37 Sunsets registered in California. Today, only one surviving Sunset automobile is known to exist.

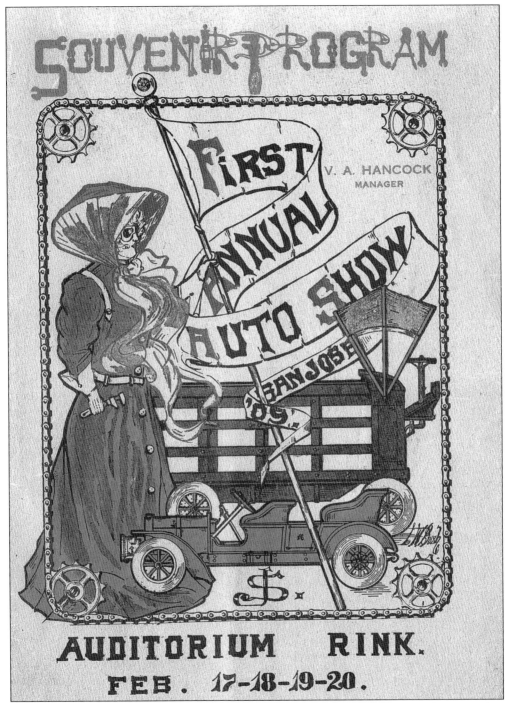

This Edwardian lady in her driving costume, wielding a wrench, was well prepared to join other local auto enthusiasts who attended the first auto show held in San Jose in 1909. A 50-car parade preceded the grand opening in the downtown Auditorium Rink. Thousands came over the next three nights, viewing $500,000 worth of automobiles while being serenaded with musical selections from Brohaska's Orchestra.

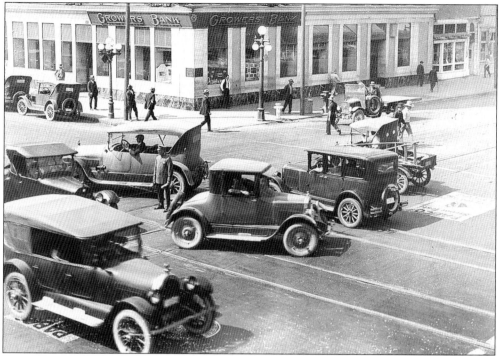

Even 75 years ago the intersection of Market and Santa Clara Streets was a busy place. But it is difficult to tell if the officer is intently watching for traffic violations or just trying to stay out of the way of passing vehicles! Across the street is the Grower's Bank, which stood at the northwest corner of Market and Santa Clara Streets. (Courtesy of San Jose State University Special Collections.)

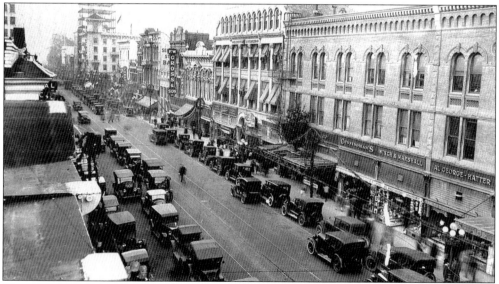

This view shows South First Street looking north from San Fernando Street in 1925. A thriving downtown is alive with automobiles and pedestrians and is in the midst of a building boom. The ten-story Commercial building rises in the background, soon to be joined by the thirteen-story Bank of Italy building. (Courtesy of San Jose State University Special Collections.)

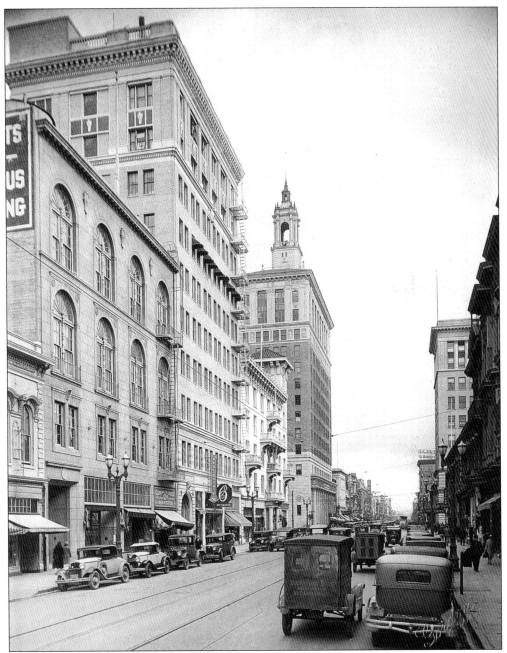

This view looking south on North First Street towards Santa Clara Street about 1929 shows a portion of the business district downtown. On the left are the Knights of Columbus building, Commercial Building, Bank of San Jose, and the towering Bank of Italy.

A photographer wishing to take this picture today would find himself dodging traffic on Highway 87! This picture was taken at the northwest corner of North Almaden and St. John Streets. The neoclassic building on the left was the College of Notre Dame Science Hall. In 1966 the Hall was demolished so that the City of San Jose could extend Almaden Boulevard northward from Santa Clara Street. (Courtesy of San Jose State University Special Collections.)

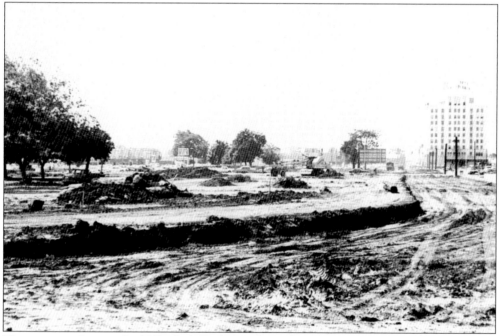

This image, taken in the Fall of 1967, shows the widening of Vine Street—which became Almaden Boulevard two years later—as the west side of downtown is re-imagined for the Park Center Plaza development to come. Looking north towards the De Anza Hotel from the corner of what is now Almaden and Park Avenues, there is no trace of the structures that stood on these blocks just a few years earlier.

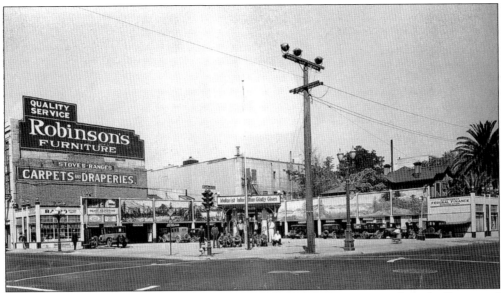

Local drivers and visiting motorists could satisfy all their automotive needs at the Bemis and Moe Super Service Station located at the corner of San Carlos and South Second Streets. Besides providing gasoline and full automotive service and repair, Bemis and Moe provided a feast for the eye with large murals of Lake Tahoe, Yosemite, Crater Lake, and other scenic motoring destinations. (Courtesy of San Jose State University Special Collections.)

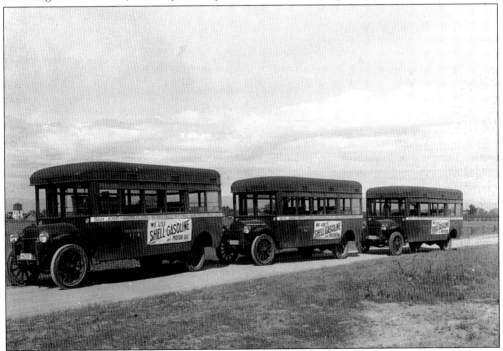

Three empty Moreland passenger buses sit on an unidentified road in April 1918. Normally they would be full of passengers, traveling the busy route between Palo Alto and San Jose with stops at Mayfield, Mountain View, Sunnyvale, and Santa Clara. They were operated by the Davis Transit Company, which had an office on West Santa Clara Street in downtown San Jose.

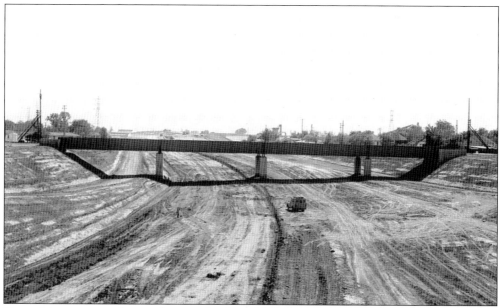

Does this curve in the road seem familiar? This is a westward view of Interstate 280 under construction as it passes under the Southern Pacific Railroad trestle at Bird Avenue. The year is 1969.

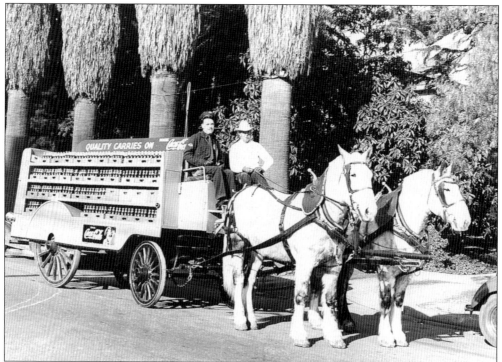

When this picture was taken in the early 1940s Coca-Cola hadn't been delivered by horse-drawn wagon for many years. This was probably a special vehicle used by the company for advertising and publicity tours. The lucky guy sitting next to the driver is local Coca-Cola salesman Ralph Laswell.

Six

SCANDALS, TRAGEDIES, DISASTERS, AND CALAMITIES

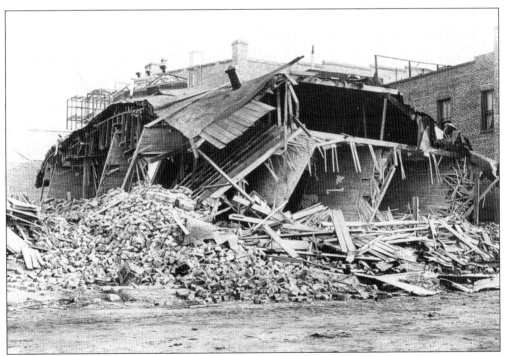

This structure was the Russ House annex, which was destroyed in the 1906 earthquake. The Russ House was a popular hotel and restaurant, which was expanded to include the inadequately reinforced annex several years before. It faced South First Street at San Antonio, about where Johnny Rockets is now. The hotel continued on without its annex for a couple of years following the earthquake, then moved to more commodious quarters in 1909.

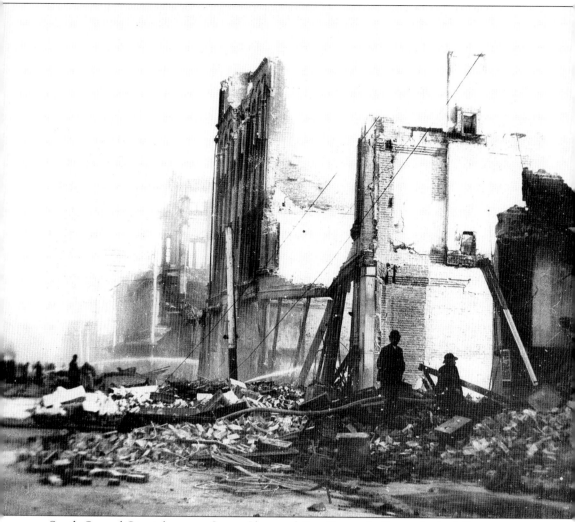

South Second Street between Santa Clara and San Fernando Streets looked like a war zone following the earthquake of April 1906, particularly on the west side of the street, as seen here. The structural damage, coupled with the fire that followed, proved devastating for this area of downtown. Though several crews of firemen are attempting to douse the flames, it is clear that just about everything is lost. The recently built five-story Dougherty Building in the middle of the block was a $100,000 loss. The three-story Louise Building on the corner, as well as the Elizabeth Building next to the Dougherty, was also reduced to rubble and ash. The total cost of damage in San Jose from the earthquake and subsequent fires ran into the millions, and much of it was due to the tremendous destruction on this block alone. Less than 15 years earlier, South Second between Santa Clara and San Fernando also suffered great loss in the fire of 1892. How unlucky can one block be?

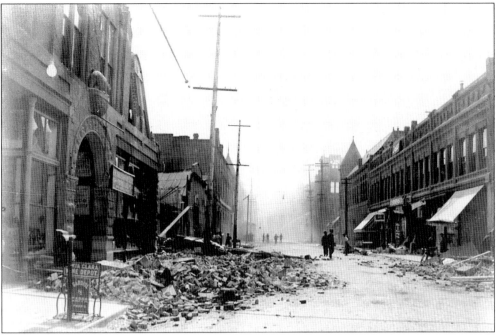

This is a westward view down San Fernando Street near the corner of Third Street where rubble has fallen into the street from several earthquake-damaged buildings. A stream of water is visible in the distance, where a group of men are dousing a fire.

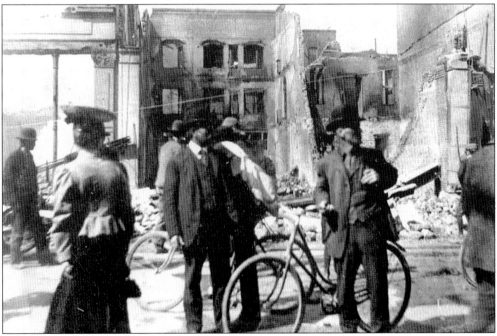

This scene of pandemonium and alarm captures the experience of downtown San Joseans on April 18, 1906, following the earthquake and while the subsequent fires were still being extinguished. This image may have been taken on South Second Street where the greatest damage occurred.

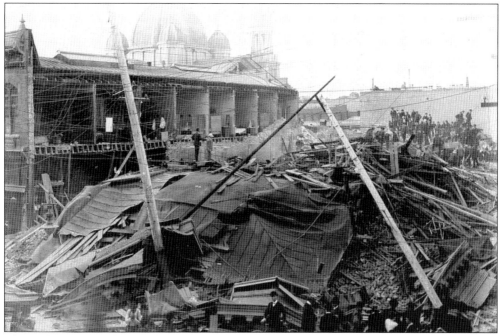

This is the scene of the completely destroyed T.W. Hobson's Clothiers building, as well as the heavily damaged Phelan Building next door to it. They stood on South First Street near Post Street. The men standing atop the rubble of Hobson's store are trying to clear away debris from the large structure. One man died when the building collapsed.

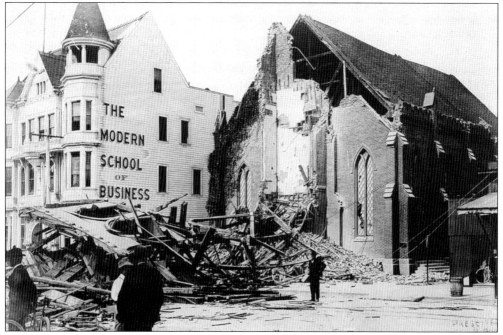

On North Second Street (near St. John) stood the First Presbyterian Church and the Modern School of Business. The former lost a large portion of its façade and steeple, which fell forward into the street.

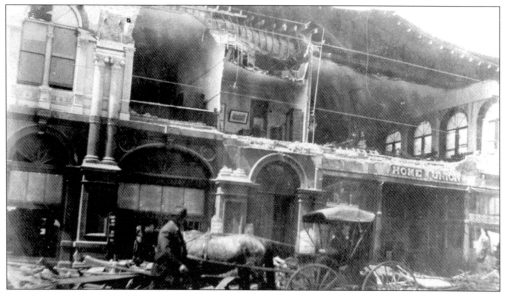

The interior of the Home Union building is left starkly exposed after the violent shaking of the earthquake caused the building's façade to crumble away. The building was at the southwest corner of Market and Post Streets. The Home Union Store on the first floor sold general merchandise, while the second floor housed the Verein Eintracht Hall.

Proclamation !

In view of the great calamity that has befallen us, and for the better police and fire protection of the city, and for the better security of life and property, I hereby recommend that all the people remain at their homes during the coming night, from and after the hour of 7:30 p.m. of this day, and I do hereby command that all persons, save and except only those who have especial business to transact therein, and permission so to do, remain away from that part of the business section of the city now being especially patrolled.

ALL LAWLESSNESS WILL BE REPRESSED WITH A HEAVY HAND

The co-operation of all good citizens is invoked in aid of the enforcement of this Order.

G. D. WORSWICK
Mayor.

San Jose, Cal., April 18, 1906.

San Jose had fire, destruction, and looting to contend with on the day of the earthquake in 1906. In addition, rumors spread that hordes of homeless citizens from San Francisco were planning to descend on San Jose, adding to the sense of panic that spread throughout the city. By afternoon, San Jose mayor, George D. Worswick, had this flyer printed and posted all over town, hoping to restore some order amid the chaos.

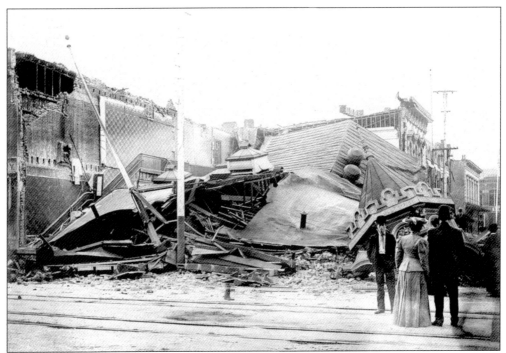

This is the site of the collapsed Elks Hall building, which stood on West Santa Clara Street at the corner of Lightston Alley.

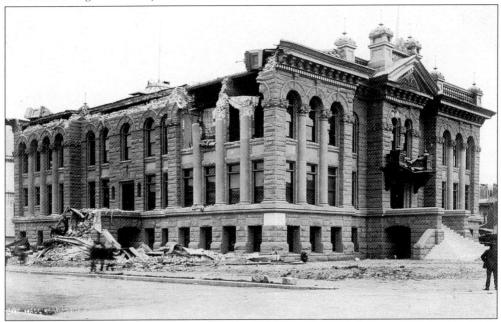

The new Hall of Justice building on the southeast corner of Market and St. James Streets was awaiting dedication when the earthquake struck. Unfortunately, the building was damaged far more than is evident from this photograph, and it had to be almost completely rebuilt. The ultimate result was considerably less ornate. The Hall of Justice stood until it was demolished in 1962. Appropriately, the superior court building stands there now.

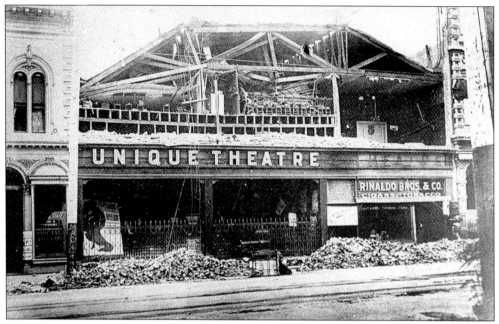

In 1903 20-year-old Sid Grauman opened the Unique Theatre with the idea of combining vaudeville acts with the new moving picture shows. When the earthquake wrecked his leased theater, Grauman moved to Southern California and opened a string of movie theaters, including the famous Grauman's Chinese Theatre. The ticket taker and mop boy at the Unique was Roscoe (Fatty) Arbuckle, who would later achieve his own show business notoriety.

POSTAL TELEGRAPH COMMERCIAL CABLES

CLARENCE H. MACKAY, PRESIDENT.

TELEGRAM

REGISTERED TRADE-MARK. DESIGN PATENT NO. 36369.

The Postal Telegraph-Cable Company (Incorporated) transmits and delivers this message subject to the terms and conditions printed on the back of this blank.

Received at Main Office, 238 South Spring St., Los Angeles, Cal. TELEPHONES { SUNSET, MAIN 640. { HOME, EXCHANGE 10.

Gs H103 2 exa

Riverside Cal. Apr. 21st, 06.

Mayor,

San Jose, Calif.

Is San Jose in need of help, if so specify what form, answer

at once. C. L. McFarland,

Mayor Riverside.

As news of the quake's devastation spread, San Francisco was not the only city to garner attention. San Jose received many generous offers of assistance from towns all over California, and many from out of state as well.

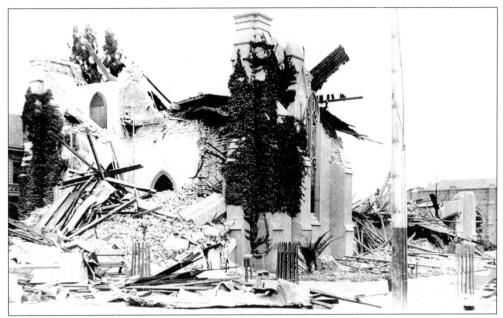

Saint Patrick's Roman Catholic Church, which stood on the northwest corner of Santa Clara and Ninth Streets, was devastated in the quake. Although reduced to rubble in a matter of seconds, its undaunted parishioners set about rebuilding on the same site. The new church served its parish for the next sixty years.

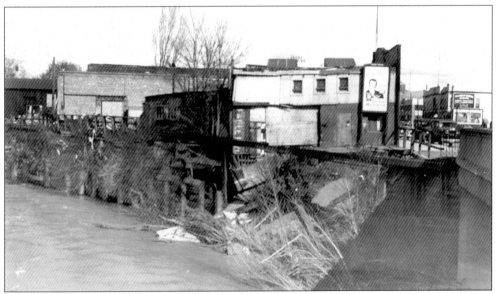

This image shows flood damage in 1941 from Los Gatos Creek at West Santa Clara Street near Delmas Avenue. This is where the creek converges with the Guadalupe River. One unstable structure, apparently hit hard by floodwaters, has collapsed into the creek.

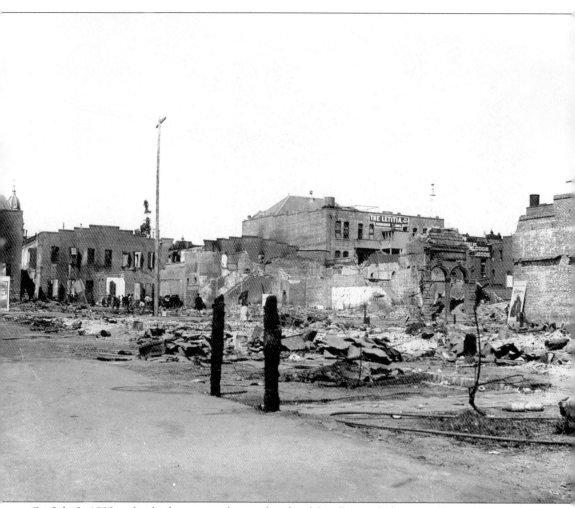

On July 2, 1892, a fire broke out on the north side of San Fernando between First and Second Streets. The fire spread quickly, first north towards Santa Clara Street, and then east nearly to Fourth Street. This image shows the devastation looking northwest near the intersection of Second and San Fernando, where the fire began. The California Theatre, seen on the far right, was incinerated. It had only recently been renovated at a cost of $50,000 and was not insured. The Letitia Building, which still stands on South First Street, is seen in the center of the photograph. The Letitia was saved by a large cartload of flour, donated by one Charles Bernhardt, who made up about a ton of paste. The paste was then slathered onto the sides of the building by helpful bystanders and this somehow managed to protect it. The most devastating fire San Jose had ever seen counted more than 40 homes, factories and businesses among the losses, totaling nearly half a million dollars. Less than half of those structures were covered by insurance.

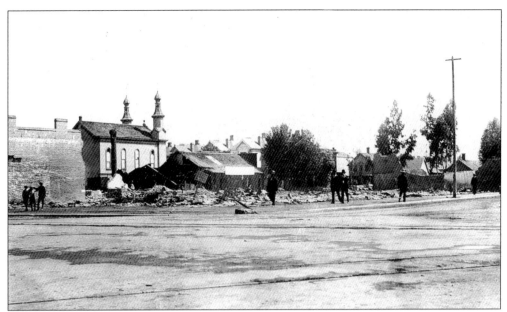

Looking northeast from the corner of Second and San Fernando Streets, we see further devastation from the fire. The German Methodist Church, which faced Third Street, escaped damage, but Belloli's market, which stood at the corner of Third and San Fernando, was leveled. Later it was rebuilt. If the men seen here were walking in the same spot today, they might be considering P.F. Chang's for lunch, and not thinking of the great loss around them.

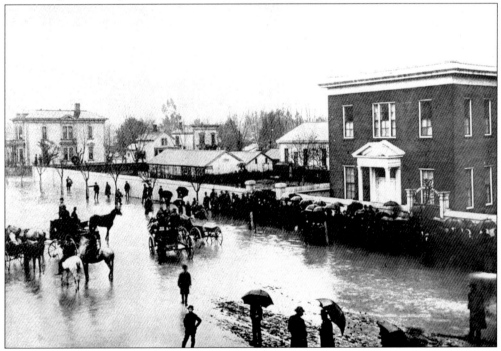

This scene shows citizens of San Jose dealing with the challenges of yet another flood, this one in the winter of 1890. It was taken just outside of Notre Dame College, which stood on Santa Clara Street near the corner of Santa Teresa Street. This is now the site of the De Anza Hotel.

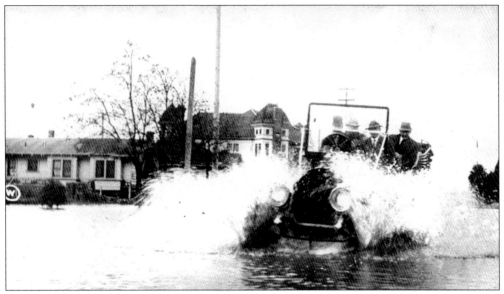

In 1911, San Jose had the wettest January recorded to that date—12.38 inches of rainfall in a single month. This can be compared with our current *seasonal* average of 12.34 inches. As the ground became saturated, the area could not absorb or drain the 2.62 inches that fell on March 7. The flood that followed washed out the Alum Rock Park rail line, swept away bridges across the valley, and inundated hundreds of acres of crops. The valley had a total of five inches of rain in as many days. In the image above, a group of men are navigating the flooded streets in their Mitchell Six automobile on South First Street near Floyd Street. In the photo below, the two men steering themselves down the street in a boat are near the intersection of Orchard Street (now Almaden Avenue) and Viola Avenue.

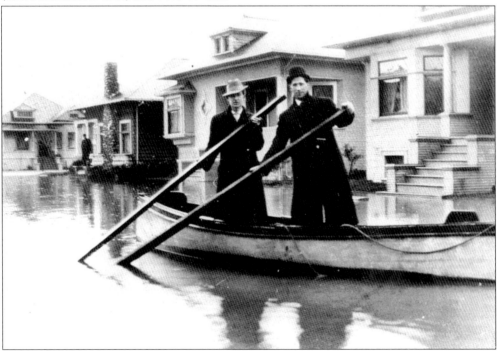

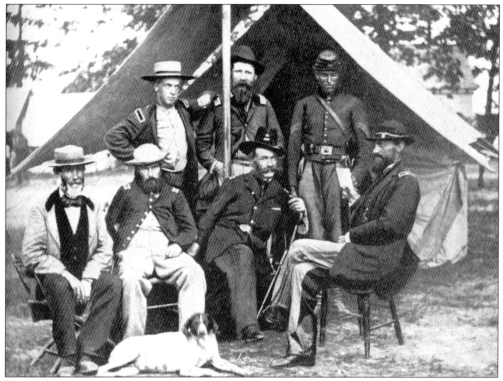

The gentleman in the center, leaning to his left, is General Henry Naglee, patriot, businessman, horticulturist, and lover. Naglee came to California in 1846 as a captain in the First New York Volunteers. When the regiment was disbanded Naglee stayed in California and became a successful San Francisco banker. During the Civil War Naglee served as a brigadier general in the Union Army. This picture was probably taken in May or June 1862, about the time of the Battle of Fair Oaks.

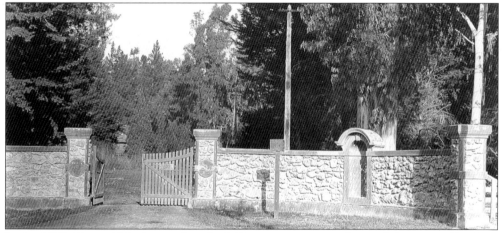

In the 1850s General Naglee purchased a 140-acre tract just southeast of downtown San Jose, eventually leaving San Francisco and taking up residence here. He had the estate grounds extensively landscaped with plants imported from around the world. Visitors were welcome to tour the grounds, entering the estate through this main gate located near the present day intersection of Eleventh and San Fernando Streets.

"Though great as a soldier, he is still greater in the art of love." So wrote the editor of a book of love letters written by General Naglee to Miss Mary Schell. The wealthy but unmarried Naglee had met Miss Schell in San Francisco. When the general ended the relationship Miss Schell considered a breach-of-promise lawsuit, but settled for the more exquisite revenge of publishing his love letters for his friends, neighbors, and fellow citizens to read.

General Naglee must have been extremely embarrassed to have his amorous writings made public. But Miss Schell added a final twist by including a sketch done by the general himself showing the half-naked Naglee exercising by doing push-ups perched above the rim of a bathtub.

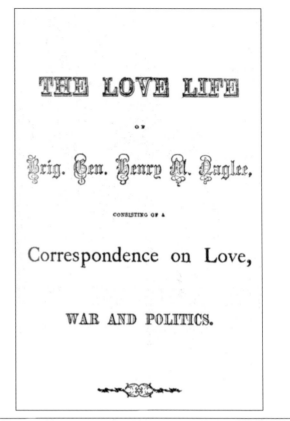

THE LOVE LIFE

OF

Brig. Gen. Henry M. Naglee,

CONSISTING OF A

Correspondence on Love,

WAR AND POLITICS.

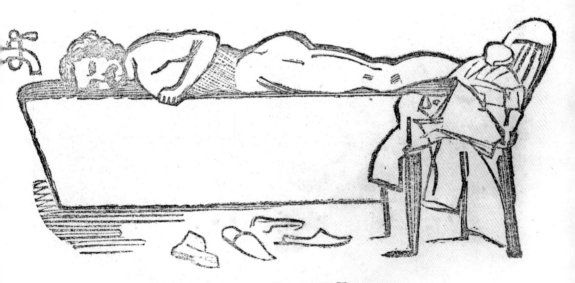

PEN AND INK SKETCH, AS DRAWN BY HIMSELF.

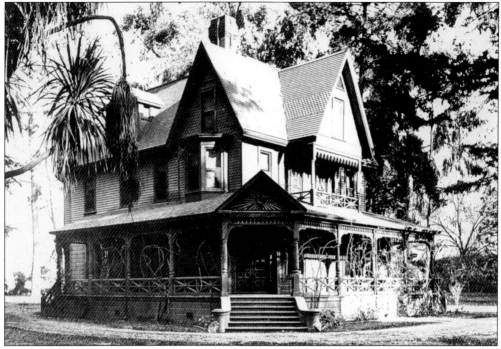

Known as the Naglee Mansion, this house was actually built in 1892 by the general's sister, Mary Naglee Burk. This photo was taken in 1902, about the time that Naglee's two daughters decided to turn their father's estate into a housing subdivision. The mansion is now an apartment house at the corner of South Fourteenth and East San Fernando Streets in the attractive neighborhood of Naglee Park.

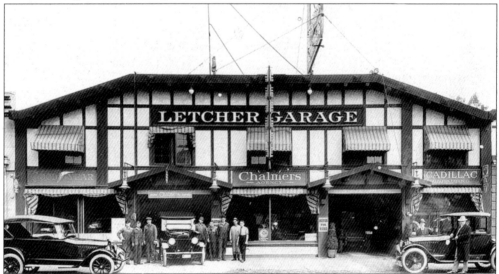

Automobile pioneer Clarence Letcher opened the first automobile garage on the West Coast and the first service station in San Jose. In 1914 Letcher opened this Tudor style garage at 214 South First near St. James. Here on the afternoon of July 2, 1926, Letcher was fatally shot by his estranged wife, who then turned the gun on herself. Today Clarence Letcher is remembered not for his innovations in automobile service, but the tragic way his life ended.

Seven

PLEASURES, PASTIMES, AND HOSPITALITY

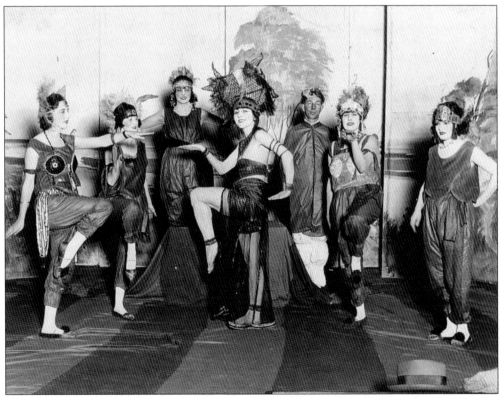

Six showgirls in pseudo-harem outfits and one bemused gentlemen grace the stage of this unnamed San Jose theater. This may be one of the Fanchon and Marco touring dance troupes who gave vaudeville performances in movie theaters before the showing of the main feature.

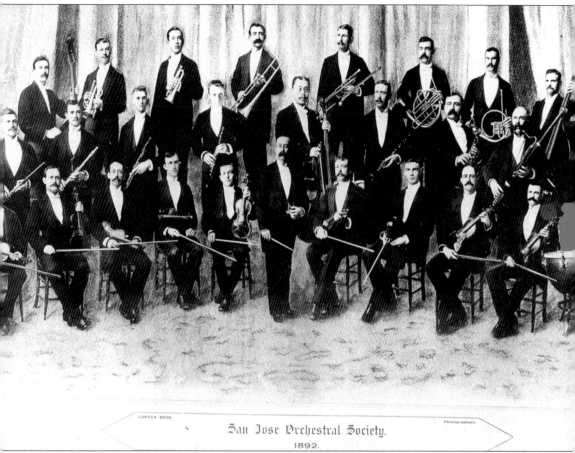

San Jose Orchestral Society.
1892.

This formal portrait of the San Jose Orchestral Society in 1892 shows that trick photography existed even at this early date. When it was discovered that clothier Leopold Hart was the only man in San Jose to own a full dress suit, photographers Milton and Archie Loryea rose admirably to the challenge of capturing the orchestra of 27 men in formal dress on camera. The Loryea Brothers, who owned a popular studio on South First Street, hit upon an idea. They would pose each of the musicians separately in Mr. Hart's dress suit, then create this incredible portrait with scissors and paste. This included a man in the front row who was actually ill at home, and was photographed in full-dress, sitting on the edge of his bed, holding his instrument! The Loryea Brothers skill is evident in the seamless arrangement of individual photos for this final portrait.

This is the Fox California Theatre as it looked in 1945. When it first opened in 1927 it was considered one of the finest theatres in California, a place where moviegoers "dressed" to attend a show. In 2001 efforts to return the film house to its original glory began in earnest. The multi-million dollar transformation will provide downtown with a magnificent performing arts facility, as well as a new home base for Opera San Jose. The grand reopening took place in September 2004. (Courtesy of the Security Pacific National Bank Photo Collection, Los Angeles Public Library.)

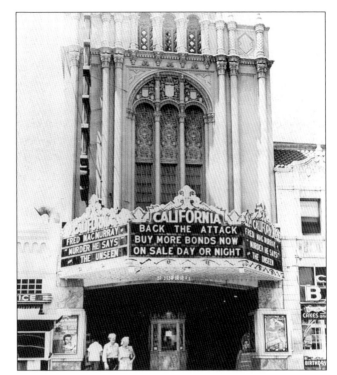

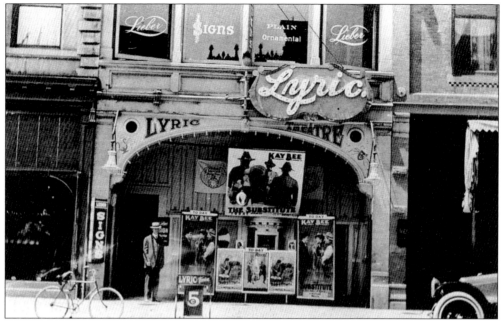

Louis Lieber, commercial sign painter and amateur actor, built the Lyric Theatre in 1913. Located at 69 South Second Street, the Lyric was one of San Jose's earliest "straight" theatres that showed only motion pictures with no vaudeville acts. The poster for "The Substitute" dates this photo to 1914 when admission was only a nickel. The Lyric was torn down in 1959 to make way for a parking lot.

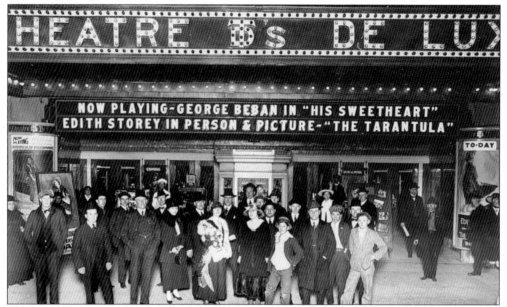

The Theatre DeLuxe, which eventually became the first stage theatre in San Jose to show "talking pictures," opened in 1912 at 236 South First Street. This photo, taken in 1916, shows a small, star-struck crowd gathered around actress Edith Storey (draped in fur and flowers), who appeared in person for the San Jose premiere of "The Tarantula." Closed in 1952, the Federal building has absorbed any trace of the theatre.

San Jose's Hotel Vendome's star service included daily trips from the Vendome stables to Mount Hamilton. Only 28 miles to Lick Observatory, the journey took six hours, including horse changes and stops. It's hard to imagine this today, but the road east of Second Street at that time was slightly uphill, which of course increased as one neared the foothills. The trip back was a comparatively speedy 3 hours and 45 minutes.

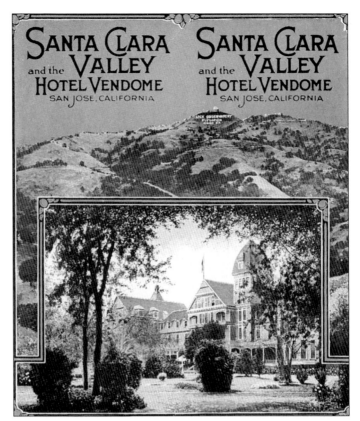

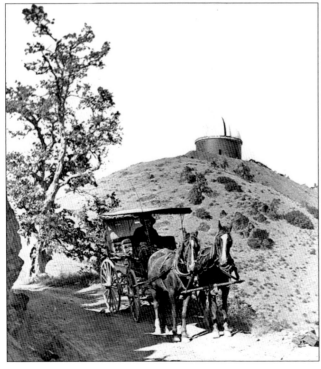

With 365 turns in the road, the journey up Mount Hamilton was in places somewhat treacherous, but this didn't deter thousands of people who wanted to see the most powerful telescope in the world at the time that Lick Observatory opened in 1888. In the early years, 5,000 people journeyed up the slow and windy road each year from the Vendome Stables. The opening of Lick Observatory brought nationwide attention, and many came to San Jose just to see it.

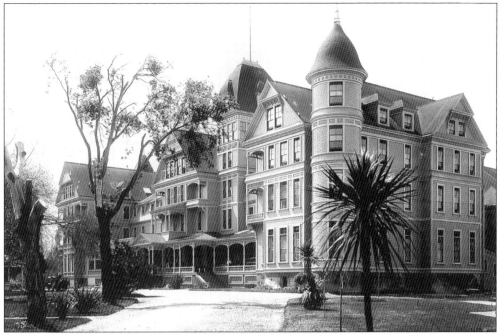

The sumptuous Hotel Vendome on North First Street was the crown jewel of local hotels. Built in 1887 at a cost of $300,000, most of the 250 guest rooms were suites and had their own bathrooms. The hotel's heyday ended in the 1920s, yet many were sad when the hotel was torn down in 1930. The land was then subdivided into several blocks of houses, which still stand today.

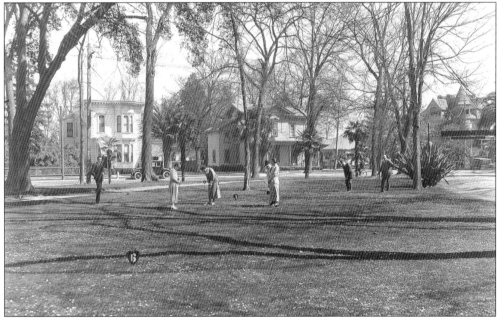

Guests at the Hotel Vendome enjoyed a variety of activities, including this jolly game of croquet on the expansive front lawn of the 12-acre site. Taken in 1923, the camera is pointed towards the corner of North First and Empire Streets. At that corner on the southeast side, one can glimpse the magnificent mansion of attorney Joseph H. Campbell.

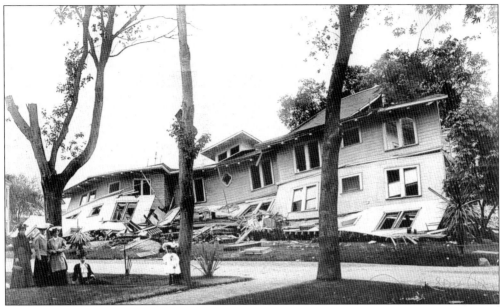

In 1903, the owners of the Hotel Vendome added an annex just northeast of the main building to accommodate the many people who wished to stay at the hotel. But just three years later, the building collapsed during the great earthquake. Fortunately, no one was injured. The management, however, thought better of rebuilding the structure, and decided instead to erect a sturdy building that contained an indoor swimming pool.

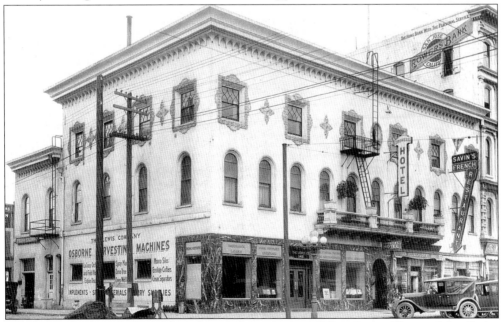

This building, which still stands at the northeast corner of West Santa Clara and San Pedro Streets, once housed one of the finest French restaurants in Northern California. Opened by French native Madame Vueve in 1872, Lamolle House served gourmet French meals under the direction of former Delmonico's chef Alexis Gaston. When this picture was taken in the early 1920s Lamolle house had closed, replaced by the Growers Hotel.

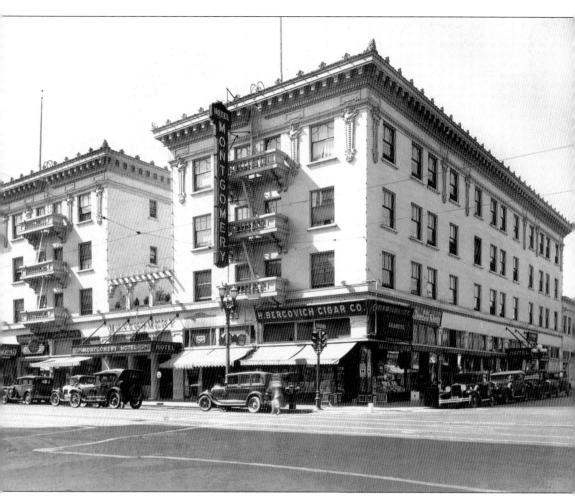

Enterprising young Thomas S. Montgomery, a 20-year-old apprentice at a real estate and insurance company on First near San Carlos Street, stepped out for a breath of fresh air one day. Peering down the street, he suddenly had a vision. He saw towering structures of brick and stone, and the bustle of prosperous business activities. Montgomery was the guiding hand in the development of many structures in San Jose, including the Vendome Hotel, the Twohy building, the Sainte Claire Hotel, and the self-named Montgomery Hotel, seen here in the mid-1920s. Hard times eventually hit the hotel, and it spent many years vacant. It was rescued from demolition and money was found to restore it. But first, the structure had to be moved 186 feet south to make room for the Fairmont Hotel's annex in early 2000. This event made the record books: it was the heaviest building ever relocated intact on rubber tires. After extensive renovation, the hotel reopened in July 2004. (Courtesy of San Jose State University Special Collections.)

Thomas Montgomery was born in San Jose in 1855. While still in his early teens, circumstances forced him out on his own. Incredibly resourceful, energetic, and positive, he not only finished his education, he quickly rose to wealth. T.S. Montgomery is generally considered the most influential developer in downtown San Jose from the late 1880s through the 1930s. (Courtesy of the Sourisseau Academy.)

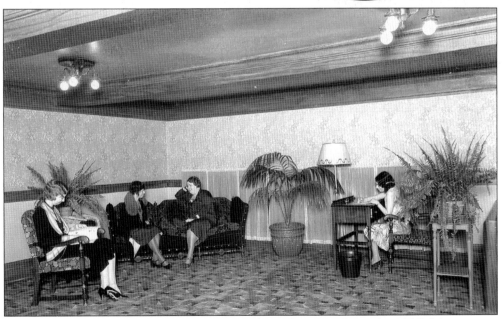

The Montgomery Hotel was built in 1911 just down the street from where T.S. Montgomery first apprenticed, on the corner of First and San Antonio Streets. It was the first hotel in San Jose lit by electricity. Designed in the Classical-Revival style, it was beautifully furnished, had two dining rooms, a ballroom, and a roof garden. The ladies writing room was located on the mezzanine level of the hotel. (Courtesy of the Sourisseau Academy.)

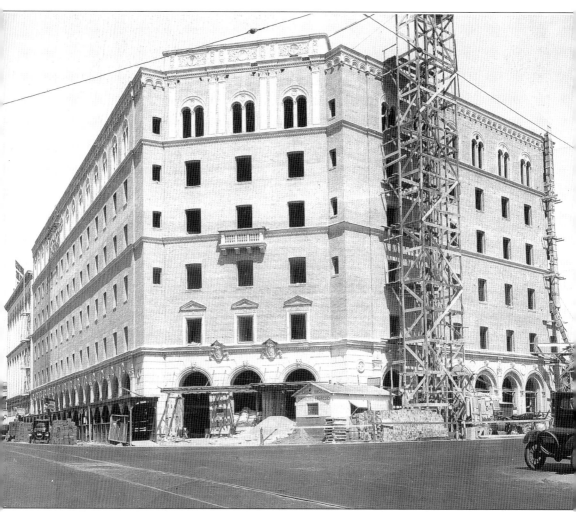

With his passionate interest in the southern portion of downtown San Jose, key developer T.S. Montgomery was especially pleased in October of 1926 to see the completion of the Hotel Sainte Claire on the southeast corner of Market and San Carlos Streets. He had successfully persuaded many to invest in this particular vision. Here we see San Jose's "million dollar hotel" as it is being constructed. At the time, it was considered the largest and most luxurious hotel between San Francisco and Los Angeles. Montgomery chose John A. Newcomb to manage the hotel, a man who valued high quality and oversaw the installation of first-class interior building materials and furnishings. Newcomb made every attempt to purchase as much as possible from local establishments. $125,000 was spent on walnut bedroom suites (bought from Robinson's Furniture Store just down the street), imported dining room chairs, and silver-plated tableware made by Reed & Barton. An elaborately painted ceiling in a sumptuous lounge (added after Prohibition was repealed), a ballroom, and marble floors were included in the many luxurious amenities.

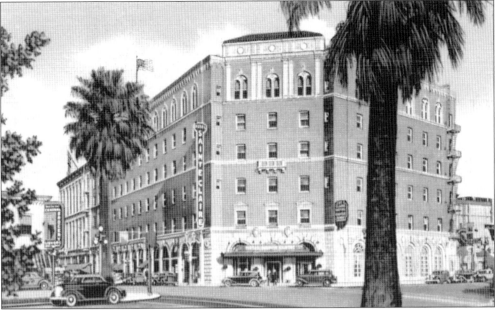

Though the Hotel Sainte Claire has seen its ups and downs over the years (including being closed for two years in the late 1980s), it was beautifully renovated in 1992 and is considered one of the nicer "boutique" hotels in downtown today.

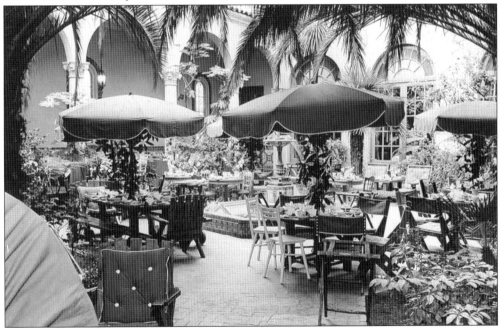

The patio at the Hotel Sainte Claire is remembered especially for its beautiful Spanish-style tile fountain. A lovely pillared portico also lined one edge of the courtyard. All of this was covered over in the 1950s. During the 1992 renovation, attempts were made to recreate the courtyard and restore some of the original ambiance. But the fountain was not replaced, and the pillared area of the patio is now part of the first-floor ballroom. (Courtesy of San Jose State University Special Collections.)

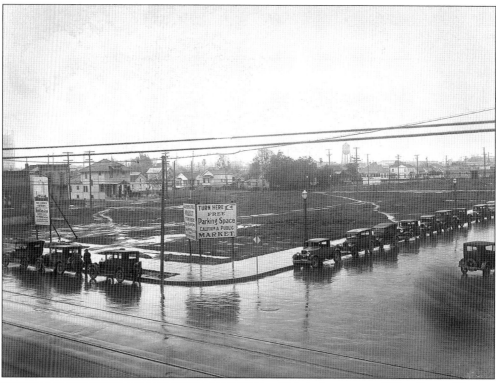

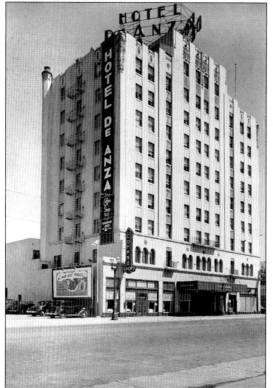

This is the corner of West Santa Clara and Notre Dame Streets about 1930, when the dream of the De Anza Hotel—then thought of as Hotel San Jose—existed, but construction had not yet begun. Designed by the architectural firm of William Weeks, the Hotel De Anza became a study in art deco design befitting its era. (Courtesy of San Jose State University Special Collections.)

The Hotel De Anza opened its doors in February 1931. It attracted a younger and more stylish crowd than the somewhat staid and conservative Sainte Claire Hotel. The hotel's heyday was the 40s and 50s, followed by a gradual decline. The multi-million dollar renovation in 1990 gave modern-day San Jose an elegant destination point with nicely appointed rooms, fine dining, and a popular local jazz spot in the hotel's Hedley Lounge. (Courtesy of San Jose State University Special Collections.)

The Auditorium Rink opened in 1909, occupying prime frontage on Market just north of San Carlos Street. Besides roller-skating, the management of the Auditorium Rink offered such diverse entertainment as dances, basketball games, bicycle races, flower shows, and poultry exhibitions. Despite these efforts the rink was not a financial success and was demolished in 1918. The space is now home to the Casa de Pueblo Retirement Community.

Just three weeks earlier these rival teams had played for the 1926–1927 San Jose Winter Baseball League Championship. Now they were meeting in an exhibition game at Sodality Park to raise money for Warren Van Dusen, a young Winter League player whose skull had been fractured by a pitched ball. The Laundrymen from Consolidated Laundry defeated the Cigarmen from Carroll & Bishop by a score of 2 to 1, raising $121 in the process.

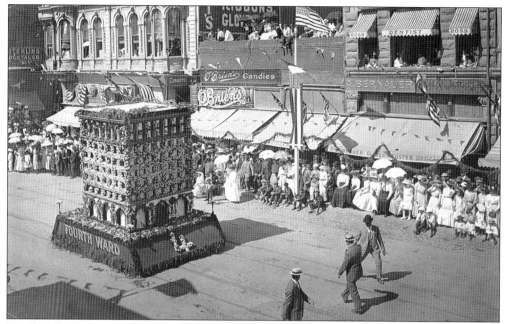

Parade officials keep a close eye on the Fourth Ward Float during the May 1910 Carnival of Roses Parade. The parade is proceeding south on First Street and is just passing O'Brien's Candy Store at 30 South First Street. The Fourth Ward was a local political district that included the southwest part of downtown. The float represents the new First National Bank building that was then nearing completion.

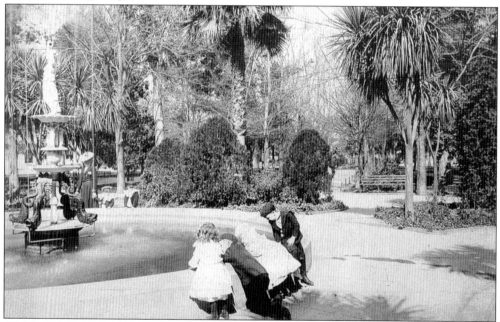

Children and adults alike enjoyed watching the fish in the picturesque fountain that once stood in St. James Park. WPA workers removed the fountain in the 1930s. The site then served as a forum for occasional soapbox orators until the City of San Jose extended Second Street through the park in 1955. This photo was taken about 1905.

Eight
ABOVE DOWNTOWN

Looking over San Jose c. 1940, the old City Hall stands grandly in the Plaza, the centerpiece of downtown. Yet with the exception of the post office building and the Civic Auditorium, all of the buildings that surrounded City Plaza are now long gone. Note the many homes and small businesses that surround the Civic Auditorium. The move out of downtown and into the suburbs was still in the future.

This is a northwest view across downtown from Fourth Street about 1940. Note the San Jose State College gymnasium in the lower right corner of the photograph. At that time, the Bank of Italy building, at thirteen stories, stood taller than any other in downtown. Just north of downtown, beyond the Southern Pacific rail yards, lie the still pastoral farmlands of the valley.

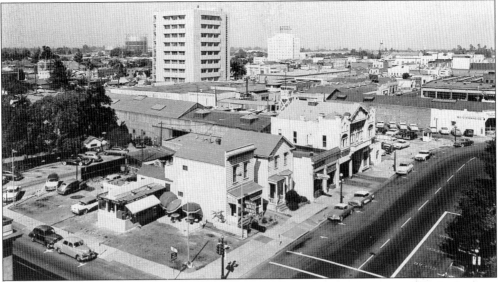

This is Market Street west of the old City Hall at the intersection of Park Avenue, c. 1950–1955. It shows a few sleepy businesses dwarfed by the Pacific Telephone and Telegraph building and the De Anza Hotel in the distance. The Bank of America stands on this corner today, the southeast portion of Park Center Plaza.

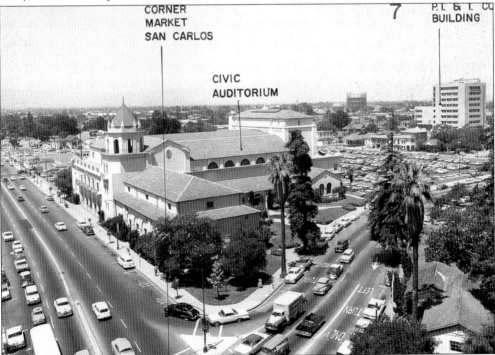

Just a bit further south on Market at the intersection of San Carlos Street in 1960, we see the current location of the Tech Museum in 1960 when it was the Civic Auditorium parking lot. Some may also remember the USO building, seen at the southern edge of City Plaza. What many may not know is that it was built in a single day in 1941 by 150 union volunteers. It was torn down in 1976.

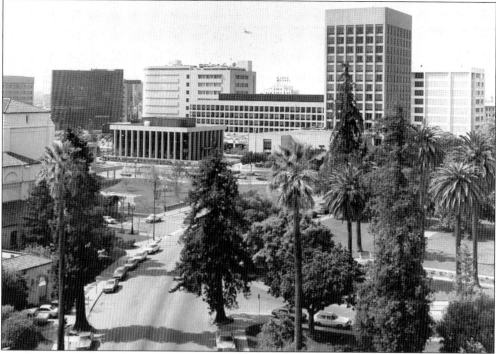

Just 20 years later the skyline surrounding City Plaza has been transformed. Homes and business have been torn down to make way for Park Center Plaza and other office developments. Already the De Anza Hotel is almost completely obscured, but even more changes to the landscape were yet to come.

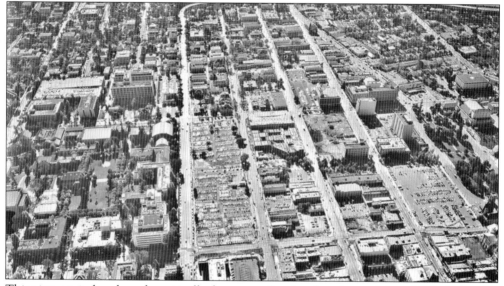

This view reminds us how dramatically downtown San Jose has changed since 1981. Before the Fairmont Hotel, before the Pavilion Shops and Paseo de San Antonio transformation, before the multi-block Paseo Plaza residential and shopping development, downtown was in search of an identity. This image shows San Fernando Street in the foreground, taken between First and Fourth Streets, looking south. (Courtesy of Pacific Aerial Surveys.)

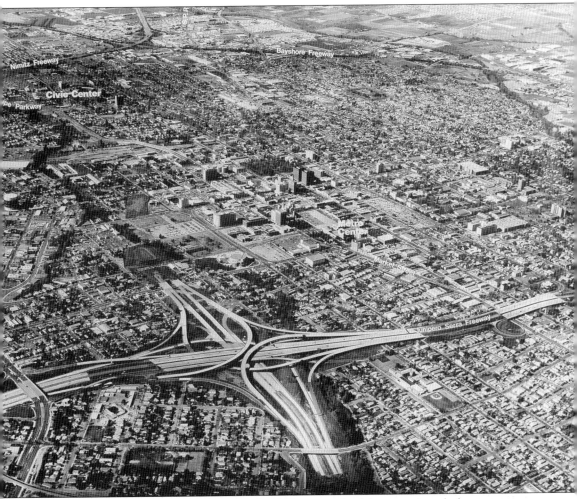

By the early 1970s, the proximity of Interstate 280 just south of downtown made for easy access into—and, indeed, away from—the center of town. With the Park Center Plaza project not yet fully realized, the west side of downtown was a patchwork of empty blocks and parking lots. Many older homes and businesses had been cleared to make room for new development, but San Jose's reinvention was still in the early stages. Note the newly-built Center for Performing Arts, facing two empty lots on either side. Highway 87, which crisscrosses 280, was still many years away from completion.

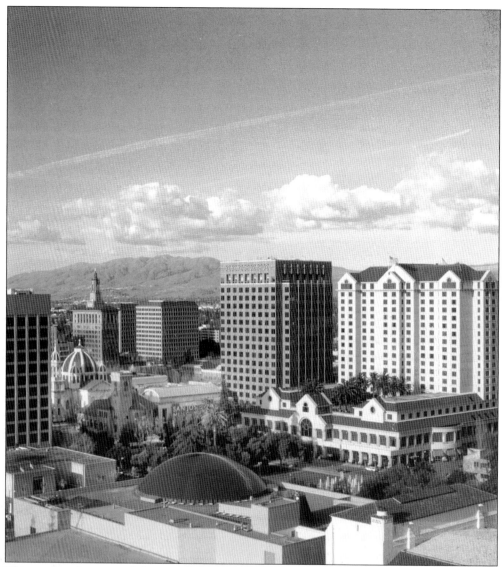

This modern-day view of the city plaza, now known as Plaza de Cesar Chavez, reveals some of the transformation that has taken place downtown in recent years. In the foreground is the Tech Museum of Innovation, complete with its dome for the IMAX theatre. To the left of that is the partially visible Bank of America, one of the earliest structures of the Park Center Plaza development of the 1960s and 1970s. On the other side of the plaza are the 800-room Fairmont Hotel (including the annex) and the Knight Ridder building beside it. Few remember that the fountain in the center of the Plaza commemorates the old City Hall, which once stood there. The old post office building, now housing the San Jose Museum of Art, along with St. Joseph's Cathedral and the old Bank of Italy building are now dwarfed in the city skyline by newer structures. (Courtesy San Jose Convention and Visitors Bureau.)

Nine

A SENSE OF COMMUNITY

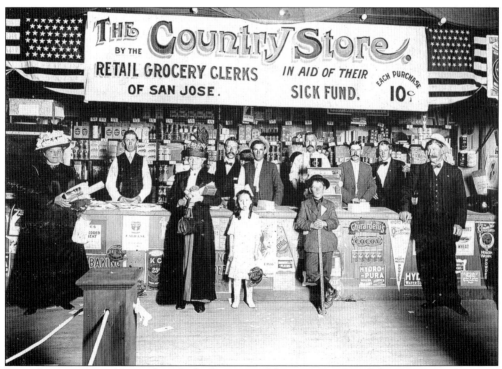

Though we were unable to identify the location of this store, we found the image too charming not to include in this collection. Taken about 1910, we see customers and sales clerks alike posing for the camera. Although its setting is a mystery, we wonder if this might have actually been a booth at the Santa Clara County Fair or a similar event, and not a store at all. We can see that this is a fundraiser for the Retail Grocery Clerks of San Jose (a union) to add to the coffers of their sick fund. It is our guess that the "customers" posed in front of the counter may be relatives of the hard workers they are supporting.

This modest sycamore and the well-worn building beside it were once considered a landmark to early settlers, a signal that they had arrived in San Jose. The "Sentinel Tree" was thought to be about 400 years old at the time this photo was taken in 1904. Formerly twice as tall as it appears here, the top half cracked off in a storm in the 1890s. The building beside it is believed to be the Sutter House, an inn that welcomed weary travelers as early as 1840, although the sycamore itself lasted far longer than the hotel. Still standing in the 1950s when a suburban neighborhood rose around it, it was not until March of 2000 that the tree was finally removed. The owners of the property at that time feared that the tree would fall on their house at 590 North Twenty-first Street.

When San Jose was included as a stop on President McKinley's 1901 visit to California, plans were made to hold a Carnival of Roses in his honor. McKinley arrived on the afternoon of May 13, 1901 to a tumultuous welcome. St. James Park held 10,000 people jammed together to hear the President thank them for their warm welcome, which was "more interesting, more generous and more memorable" than any he had ever received before.

His wife's illness forced President McKinley to leave San Jose early. But the planned festivities continued, including the Carnival of Roses floral parade featuring bands and fifty floats. Here the San Jose State Normal School float "Education" passes in front of the reviewing stand on First Street. In the background, natives of Ohio gather on the county courthouse steps, honoring McKinley, a native of the Buckeye State.

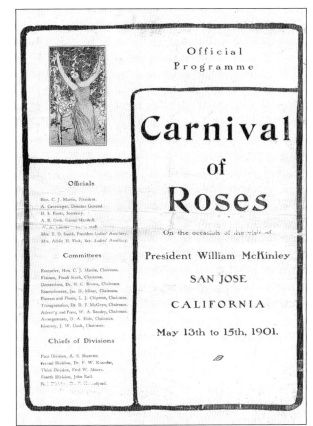

Official Programme

Carnival
of
Roses

On the occasion of the visit of

President William McKinley

SAN JOSE

CALIFORNIA

May 13th to 15th, 1901.

Officials

Hon. C. J. Martin, President.
A. Greninger, Director General.
H. S. Foote, Secretary.
A. B. Cosh, Grand Marshall.
W. A. Coulter, Chief of Staff.
Mrs. E. O. Smith, President Ladies' Auxiliary.
Mrs. Addie H. Fink, Sec. Ladies' Auxiliary.

Committees

Executive, Hon. C. J. Martin, Chairman.
Finance, Frank Stock, Chairman.
Decorations, Dr. H. C. Brown, Chairman.
Entertainment, Jas. D. Miner, Chairman.
Flowers and Floats, L. J. Chipman, Chairman.
Transportation, Dr. D. F. McGraw, Chairman.
Advert'g and Press, W. A. Beasley, Chairman.
Arrangements, O. A. Hale, Chairman.
Itinerary, J. W. Cook, Chairman.

Chiefs of Divisions

First Division, A. E. Shumate.
Second Division, Dr. F. W. Knowles.
Third Division, Fred W. Moore.
Fourth Division, John Reil.
Fi... Di... Dr. F. H. ...odyard.

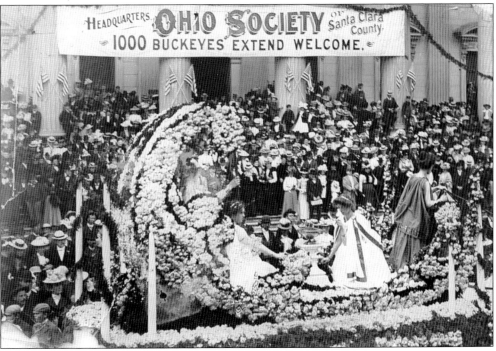

Four months later President McKinley was struck down by an assassin's bullet. With his recent visit still fresh in their minds, the devastated community raised $13,000 to erect a statue in his honor. It depicts an overcoat-clad McKinley striding forward with one hand extended. The statue was dedicated on February 1, 1903, standing on the same spot in St. James Park where he had been so lavishly welcomed.

In 1903, President Theodore Roosevelt took a fancy to the idea of visiting the West. He began his tour through California in Redlands and arrived in San Jose to great fanfare five days later. Here he is seen being welcomed by the crowd at the Bassett Street Station.

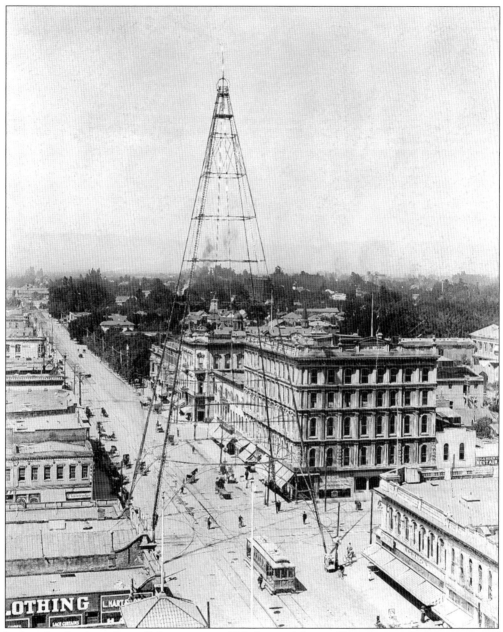

Its legs firmly planted on all four corners of Market and Santa Clara Streets, the Electric Light Tower was the pride of San Jose during the late 19th and early 20th centuries. It stood as a monument to progress, technology, and the vision of local newspaper publisher J.J. Owen. He convinced the city council to allow him to build a tower that would bathe downtown in electric light every night. Construction of the 227-foot iron tower began August 11, 1881. The six 4,000-candlepower carbon arc lights at the top of the tower were first lit the night of December 12, 1881. Over the years the elements took their toll and during a fierce windstorm on December 3, 1915 the structure collapsed into the intersection below. No one was hurt and the remains of the tower were hauled to the scrap yard. Today the tower lives on as a half-size replica built on the grounds of History San Jose in Kelley Park.

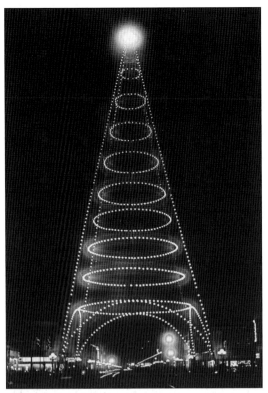

Nearby residents claimed they could read a newspaper using only the tower's light. A farmer 11 miles away near Los Gatos claimed the light was keeping his chickens awake at night. The beat cop had to keep drunks and thrill seekers from climbing the tower, but could lay claim to any ducks or game birds that crashed into the tower after being blinded by the lights. (Courtesy of San Jose State University Special Collections.)

Excited onlookers escort San Jose's Company B of the California National Guard as they march east on San Antonio Street on their way to fight in the 1898 Spanish-American War. The war ended before they could be deployed and they returned six months later. If you march down this same area today you will find yourself on the pedestrian mall between the Fairmont Hotel and the Fairmont Annex.

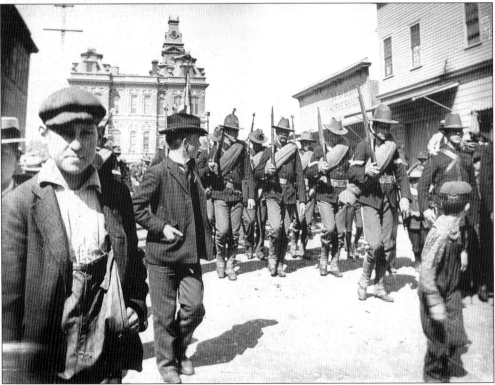

The Independent Order of Odd Fellows building was located at 92 East Santa Clara Street near Third Street. It was designed by Jacob Lenzen and Son and constructed at a cost of $30,000. The building remains today at the same location, although much altered and enlarged. (Courtesy of the Sourisseau Academy.)

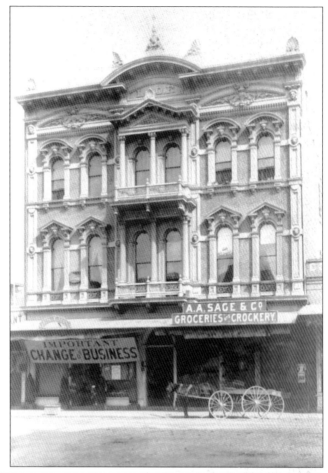

This is an interior view of the Masonic Hall *c.* 1905, which was located in the large Rutherford Building on the southwest corner of South Second and San Fernando Streets. Amazingly, the building escaped serious damage during the quake the year after this photograph was taken. This area was the most devastated in all of downtown.

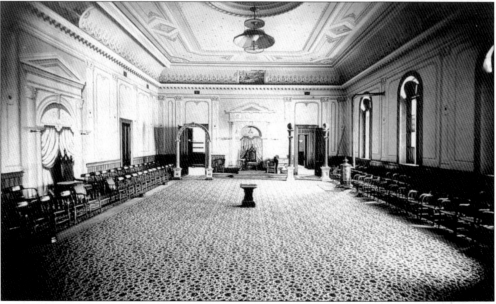

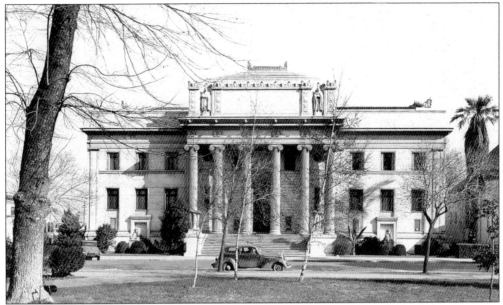

The Scottish Rite Temple stands at the corner of North Third and St. James Streets. Designed by Carl Werner, the $400,000 temple was dedicated on May 8, 1925. It boasted an auditorium that could seat 1,400 and a kitchen that could feed 1,000. When the Scottish Rite moved to a new temple south of downtown, the building received a $6 million renovation and reopened in 1981 as the San Jose Athletic Club.

Newly invested Knight Commanders of the Court of Honor pose in the San Jose Scottish Rite Temple in December 1949. Seated in front is the Sovereign Grand Inspector General for the Orient of California. The investiture took place at the Scottish Rite Temple on Third Street.

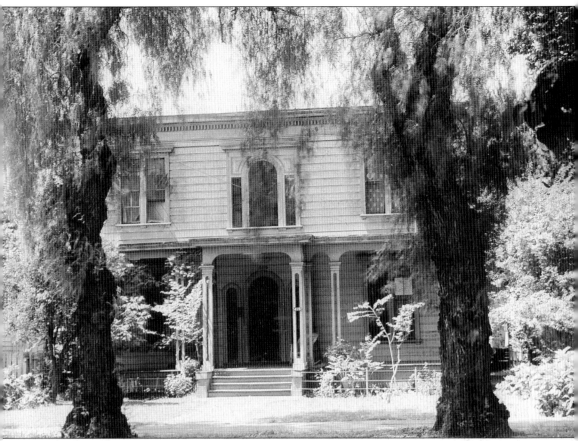

This is the home of Dr. Benjamin Cory, which stood on South Second Street from 1864 until the early 1960s. Dr. Cory was the first physician to settle in San Jose, as well as the first in Santa Clara County, when he arrived in 1847. Cory was known for his generous spirit and melodic singing voice, as well as his many civic and charitable activities. When he set out to have a new home built for his family in 1864, he was mindful of California's propensity for earthquakes, so he was determined to build the sturdiest home in San Jose. Its delicate features belie its fortress-like foundation and structure. Every interior and exterior wall was supported by a brick foundation that ran six feet into the ground. Every staircase was mortised, glued, and nailed to make sure nothing was loose or squeaked. Dr. Cory's home survived everything but the developer's bulldozer a century later.

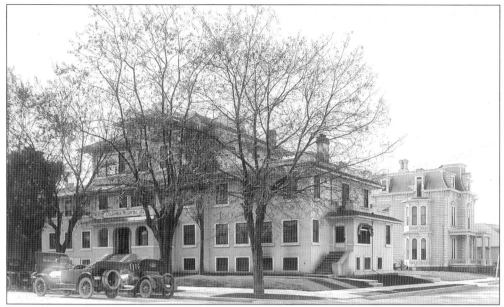

Columbia Hospital stood on South Market Street at the corner of Auzerais Avenue, seen here about 1920. The Columbia nurses occupied the old mansion at 80 Auzerais Avenue, just behind the main structure. Columbia didn't last long after San Jose Hospital opened in 1923, and the building became an apartment house for a time. The San Jose Convention Center parking garage near the Marriott Hotel takes up this space now.

Trinity Episcopal Cathedral was built in 1863 and is the sole example of Carpenter Gothic architecture remaining in San Jose. It still stands on the southwest corner of Second and St. John Streets, having undergone many renovations and additions. It is the oldest-surviving Protestant church in San Jose.

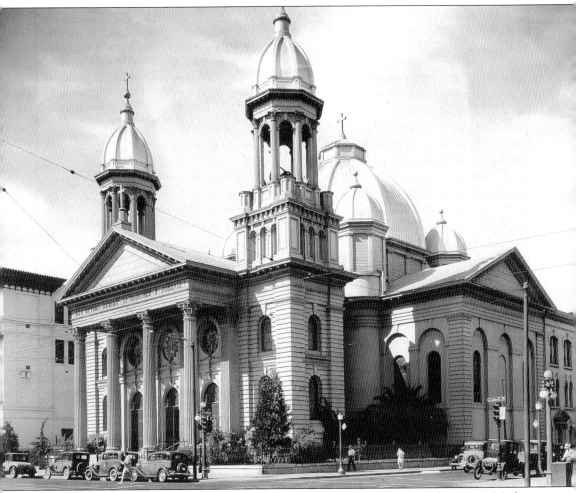

A Catholic church bearing the name of San Jose's patron saint has stood at this spot at Market and San Fernando Streets since 1803. The current St. Joseph's Church was the fifth to occupy this site, its predecessors having succumbed to earthquakes or fire. The beautiful church shown in this photo, designed by Brian Clinch in the shape of a classic Greek cross, was dedicated on April 22, 1877, then the largest Catholic Church in California. Construction was completed in 1885 at a cost of $100,000. Unlike neighboring buildings, Saint Joseph's survived the 1906 earthquake with little damage. In 1990 a four-year, $17 million building renovation was completed. The building was not only strengthened, but the paintings, murals, statuary, altars and other works of art were all restored. Upon completion, St. Joseph's was designated a cathedral by the Vatican, the seat of the bishop of the Diocese of San Jose. In 1997 St. Joseph's Cathedral was named a basilica, one of only five churches in California so honored.

This photo of the interior of St. Joseph's was taken on Easter Sunday, 1925. The main altar is Carrera marble donated by Edward McLaughlin. A year later Fr. Luigi Sciocchetti added the beautiful murals to the walls and ceilings that grace the cathedral today.

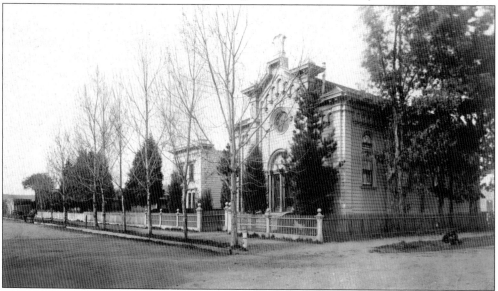

The Congregation Bickur Cholim Synagogue stood at the northeast corner of San Antonio and Third Streets. Dedicated in August 1870, it was built at a cost of $5,200. The building measured 40 feet by 60 and could seat 206 members. The synagogue stood on this spot until it was destroyed by fire in 1940. (Courtesy of the Sourisseau Academy.)

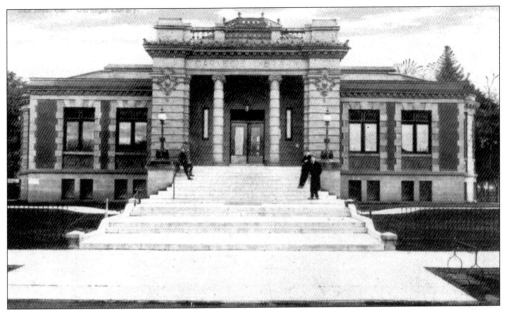

For years the public library occupied cramped quarters in city hall, accessible only by a long climb up two flights of stairs. In 1901 Andrew Carnegie donated $50,000 to build a new library. A site was selected at the corner of Fourth and San Fernando Streets on the campus of the Normal School. The cornerstone was laid in February 1902 and the library was officially opened on June 1, 1903.

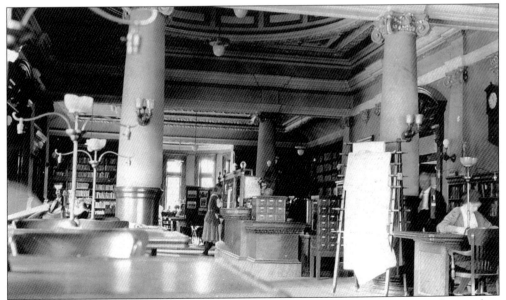

A young lady stands at the checkout desk in this interior shot of the Carnegie Library taken around 1907. One of the two reading rooms can be seen in the background. What at the time seemed a spacious building was outgrown within five years. But it wasn't until 1937 that the library was able to move to larger quarters in the former San Jose Main Post Office.

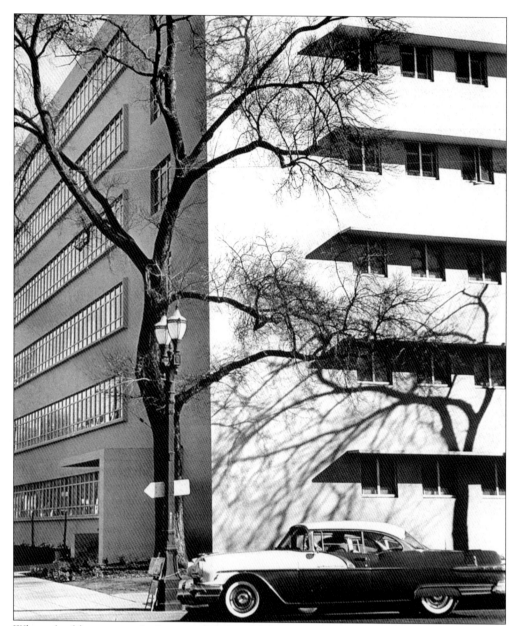

When the library moved, the city sold the old Carnegie building to San Jose State College, where it served as the student union. In 1960 the College demolished the old public library to make room for an expansion of the college library. Thus in 1961 this six-story library annex rose on the site of the old Carnegie Library. Eventually named for San Jose State President John T. Walquist, the Walquist North annex was then the tallest building on campus. Its opening coincided with considerable criticism over San Jose State's architectural style—or lack thereof. In 1961, *Western Architect and Engineer* magazine complained of "the stark new buildings bearing little relation to each other and none at all to the original construction." Despite the less than enthusiastic welcome, Walquist North housed library collections and the college's division of library science for nearly 40 years. It was torn down in 2000 to make way for—you guessed it—a new library. (Courtesy of San Jose State University Special Collections.)

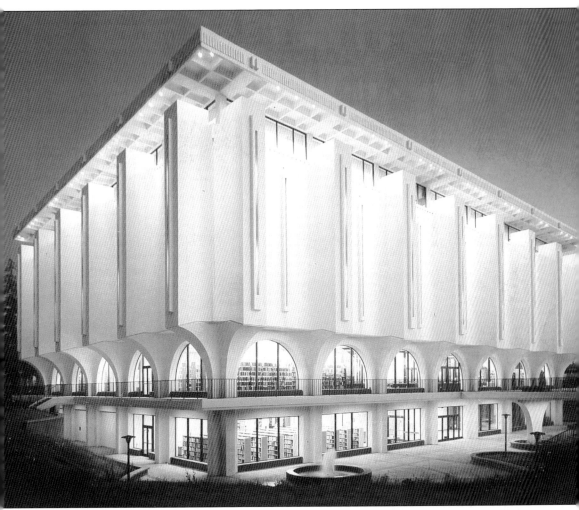

In 1970, after 33 years in the old post office building, the San Jose Main Library was able to move into this modern new building at 180 West San Carlos between Market Street and Almaden Boulevard. The $4.7 million structure featured a contemporary design with a hint of San Jose's Spanish past in the first floor arches. The building has six levels and 112,000 square feet. On January 11, 1990, the main library was rededicated in honor of Dr. Martin Luther King Jr. In the late 1990s the need for more space and technological upgrades led to an agreement between the City of San Jose and San Jose State University to build a new shared library. In August 2003, after 33 years in this location, the King Main Library moved once again, to a new joint city/university library located on the campus of San Jose State University.

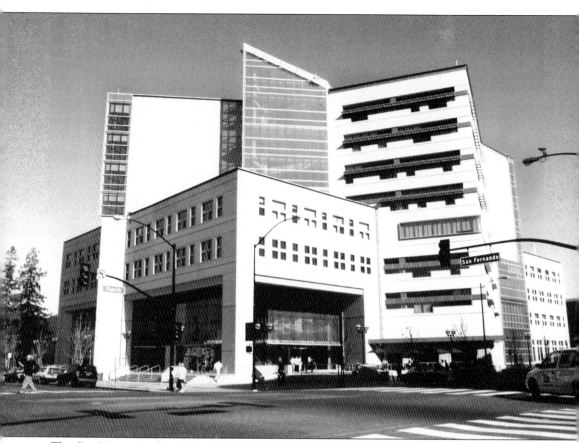

The Dr. Martin Luther King Jr. Library opened on the corner of Fourth and San Fernando Streets in August of 2003. It is the third library to stand on this corner in the last 100 years. The Carnegie library, which served the public for 34 years, opened in 1903. In 1937 the library collection was moved to the former post office building at San Fernando and Market Streets, and San Jose State College then used the former public library as their student union. The building was razed in 1960, and an extension of the college library, the six-story Wahlquist tower rose in its place. In 2000, the Wahlquist library was demolished to make way for a new library that would serve both San Jose State University students and faculty and San Jose's community at large. This joint venture is the first of its kind in the nation—a collaboration between a major city and a major university. The merged staff shares the goal of supporting lifelong learning and providing accessible information to every member of the San Jose community. (Courtesy of Lisa Inman.)